IMAGES
of America

ORLEANS

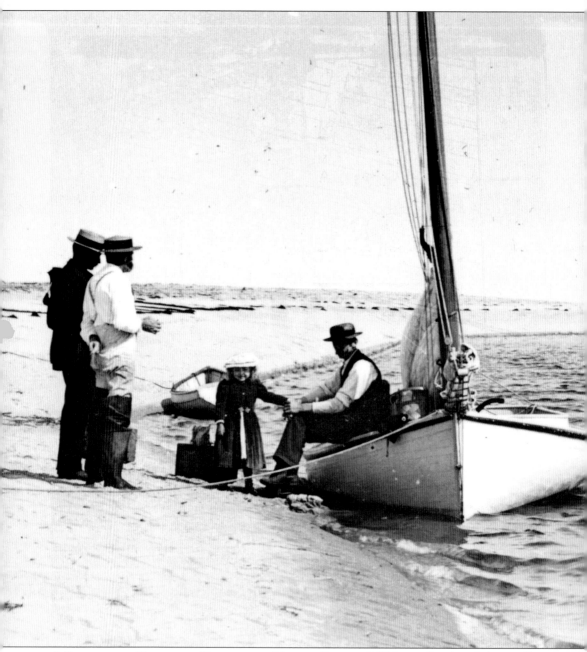

A FATHER AND DAUGHTER BOATING AT NAUSET BEACH. Off Nauset Beach, a father and his daughter share some time together. (Photograph courtesy of Mr. and Mrs. Stanley Snow.)

IMAGES
of America

ORLEANS

Daniel Lombardo

ARCADIA

First printed in 2001.

Published by Arcadia Publishing,
an imprint of Tempus Publishing, Inc.
2A Cumberland Street
Charleston, SC 29401

Printed in Great Britain.

Library of Congress Catalog Card Number: 2001088719

For all general information contact Arcadia Publishing at:
Telephone 843-853-2070
Fax 843-853-0044
E-Mail sales@arcadiapublishing.com

For customer service and orders:
Toll-Free 1-888-313-2665

Visit us on the internet at http://www.arcadiapublishing.com

ACKNOWLEDGMENTS

My deep and hearty thanks go to Bonnie Snow, historian of the Orleans Historical Society and a true town treasure. This book could not have been done without her generous contributions of photographs and her unstinting help with all aspects of Orleans history. She and Stanley Snow opened up their family photographs, his postcard collection, and their home to me throughout this project. Thanks go to Michael Parlante, a great collector who brought out many treasures for this book while we sat at the bar of the Parlante family's Book Store & Restaurant in Wellfleet. Thanks also go to Hope Morrill, accomplished curator of the Cape Cod National Seashore Archives in Eastham, to John Bosko for his recently discovered photographs, and to Lois Witt and the Orleans Historical Society for permission to use their photograph collections. My most profound thanks go to Karen Banta.

This book is dedicated to Sawyer Brooks McEwen,
Riley Kaden Johnson, Kira Bradley, and all the children to come.

CONTENTS

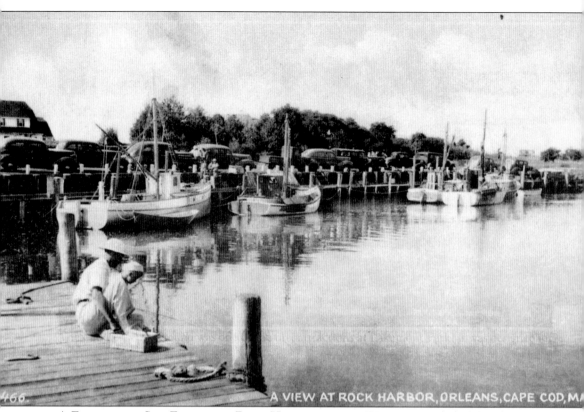

A VIEW AT ROCK HARBOR, ORLEANS, CAPE COD, M/

466.

A FATHER AND SON FISHING AT ROCK HARBOR, 1930S. We are reminded of the plain, good people of the town by this postcard and by this newspaper note printed in August 1881: "We shall all remember that whole-souled man, Robert E. Oliver, who last Saturday took from his fish weir a large quantity of large mackerel, and drove into the village, and bade all to help themselves without money and without price. Such Roberts are few in these days." Another "whole-souled" Orleans resident was alarmed to read her own obituary in December 1881: "The reported death a short time since of Mrs. Bangs Taylor was quite a surprise to herself and as well as to her family and friends. Her health is really quite good at present, and her friends hope she may be spared them for many years to come." (Postcard courtesy of Mr. and Mrs. Stanley Snow.)

INTRODUCTION

It is easy to get lost in Orleans, lost in every sense of the word. Roads twist and turn, overhung by canopies of scrub oak, always leading to water. Though the old lanes often tell you where they are going by their names, one is always astonished at the dramatic moment when the sheet of blue or the wild breakers appear. Skaket Beach Road leads to that stunning beach on Cape Cod Bay, Island View Lane looks out on Hopkins Island, and Quanset Road leads to Quanset Pond, which looks out to Pleasant Bay. Rock Harbor Road goes down to the harbor with arguably the best sunsets on Cape Cod. William Blake wrote, "Improvements make straight roads, but the crooked roads without improvement are roads of genius."

On such roads, one gets lost in history. We travel past sea captains' homes, like Captain Linnell's mansion, built with the profits of voyages to Calcutta and Hong Kong. There is Jonathan Young's windmill at the head of Town Cove, or we can go down to Nauset Beach, the long arm of sand where so many shipwrecks have scattered.

It is easy to get lost in memory and imagination, and we identify with the homesickness felt by people such as Warren Sears Nickerson. Born in 1881, in later life he recalled approaching Cape Cod on a return voyage:

> We cleared Chatham Bars, headed north up the beach, and as we opened out by Strong Island I took my spyglass and shinned up to the mizzen cross-trees. There, across the Bay, framed in the doorway of our old home with the morning sun striking full upon her, was my mother . . . that picture is as plain in my memory today as if it were yesterday. I was only about sixteen or seventeen years old, it had been a long, rough voyage, and I guess I was a little homesick.

Writer Henry David Thoreau knew well how to lose oneself and find oneself on Cape Cod. In October 1849, he stayed at Higgins Tavern on the County Road in Orleans. From there, he set out on a famous trek along the Cape. He wrote of seeing two young Italian organ grinders, and of the "saltworks scattered all along the shore, with their long rows of vats resting on piles driven into the marsh, their low turtle-like roofs, and their . . . windmills, novel and interesting objects to an inlander." On leaving town, he wrote, "We crossed a brook, not more than fourteen rods long, between Orleans and Eastham, called Jeremiah's Gutter. The Atlantic is said sometimes to meet the Bay here, and isolate the northern part of the Cape."

Another inn, that of Widow Keziah Harding, played an important part in the town's past. In 1723, Orleans was a parish of Eastham and was allowed to employ its own minister, Samuel Osborne. On March 3, 1797, Orleans was officially incorporated as a separate town. The selectmen of both towns met at the Widow Keziah Harding's Tavern to divide common property, such as books, powder, balls, and gunflints.

One hundred years later, the Shattuck House was the town's best-known inn. On August 27, 1881, the *Yarmouth Register* commented:

> The attractions of the well-known Shattuck House, have been fully enjoyed and appreciated by an unusually large number of visitors during the present season. Its fine, airy rooms, central location, and close proximity to the depot, together with its obliging host and hostess . . . and abundant table, the many fine turnouts from the extensive livery stable connected therewith, serve to class it as one of the finest hotels to be found on the Cape.

Orleans has hosted a remarkable group of heroes, pirates, fishermen, Native Americans, farmers, gypsies, and sailors of the seven seas. The first were the Nauset Indians, who fished and planted by its harbors. It was the Nausets who found John Billington, the lost Pilgrim boy, and presented him, decked out in shells and beads, to Myles Standish in 1621. One of the earlier white settlers was Isaac Snow. Born in 1758, Snow served under George Washington at Boston during the Revolution. On a voyage to Cadiz, his ship was captured by the British and taken to Gibraltar. Snow wrote:

> I was put on board of a prison-ship in the harbor, and soon saw enough of prison life, and began to think of trying to escape. Two other prisoners and myself took the time when the officers were below at dinner, and, in as still a way as possible drew up the ship's boat, so that we could slip into her from the gun port. One man was in the boat . . . We instantly told him, that if he made the least noise he was a dead man; that stilled him, and we slid the boat astern . . . those on the ship's quarter broke open the arm chest, and then the balls rattled around us like hail stones . . . We reached shore . . . jumped out and run.

Death was an all-too-present specter in early Orleans. The town was the site of the first known Cape Cod shipwreck, the *Sparrowhawk* in 1626, and the last wreck of a sailing ship on the Cape, the *Montclair* in 1927. In November 1898, most of the bodies from the wreck of the steamer *Portland*, lost in the great Portland Gale, washed up around Orleans. On December 19, 1898, the papers reported:

> Orleans has had a sad reminder of the gale of the 27th. Being the residence of the Medical Examiner (S.T. Davis), and near the localities where the largest number of bodies were washed ashore—Nauset Harbor and Eastham Beach—the town was thronged with distressed friends of the victims, newspaper reporters, and state officials. On Wednesday night there were laid the remains of six victims of the catastrophe at Mr. Steele's undertaking rooms and six at Mr. Mayo's. The town for a week was wrapped in funeral gloom.

Our lost childhoods and the primal memories of our human species mingle in places like Orleans. There, we see physical evidence of the first creation and the continual creation of new seascapes. If we lose ourselves a little in Orleans, we find the wisdom of Thoreau's words: "Not till we are lost, in other words, not till we have lost the world, do we begin to find ourselves, and realize where we are and the infinite extent of our relations."

One

THE NAUSETS AND THE FIRST EUROPEANS

What is become of those numerous tribes which formerly inhabited the
extensive shores of the great bay of Massachusetts?
—Hector St. John de Crevecoeur, 1782.

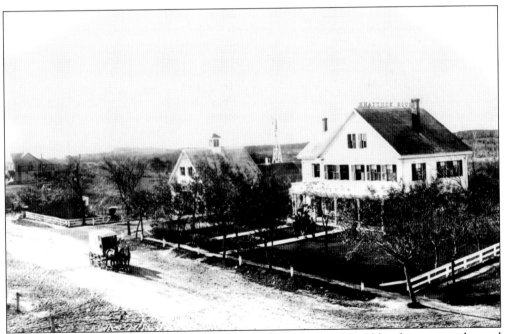

THE SHATTUCK HOUSE ON THE COUNTY ROAD, ORLEANS. Inns like this once welcomed travelers to Orleans, a classic Cape Cod village. Some say the first foreign visitors to Orleans's harbors were Vikings in the year 1003. Others followed—explorers such as Bartholomew Gosnold, who named the dangerous offshore waters "Tucker's Terror," and Samuel de Champlain, whose map shows the Native American shelters set around the harbor. There, the Nauset Indians fished, planted, and told stories of the creation of their land from a grain of sand taken from the bottom of the sea. (Photograph courtesy of Mr. and Mrs. Stanley Snow.)

THE WAMPANOAG STORY OF CREATION. "In the beginning there was nothing but sea-water on top of the land. Much water, much fog. Also Kehtean, the Great Spirit, who made the water, the land under it, the air above it, the clouds, the heavens, the sun, the moon, and the stars reached down to the bottom of the sea, took a grain of sand and of that made the earth. He created four guiding spirits to guard the four corners of the earth; and he made four winds. Then he made animals in the likeness of spirits of earth and heaven, birds in the likeness of the four wind-spirits, fish in the likeness of the Water Spirit . . . and he gave life to them all." (Elizabeth Reynard, *The Narrow Land*, Boston: Houghton Mifflin, 1934, pages 23–24.)

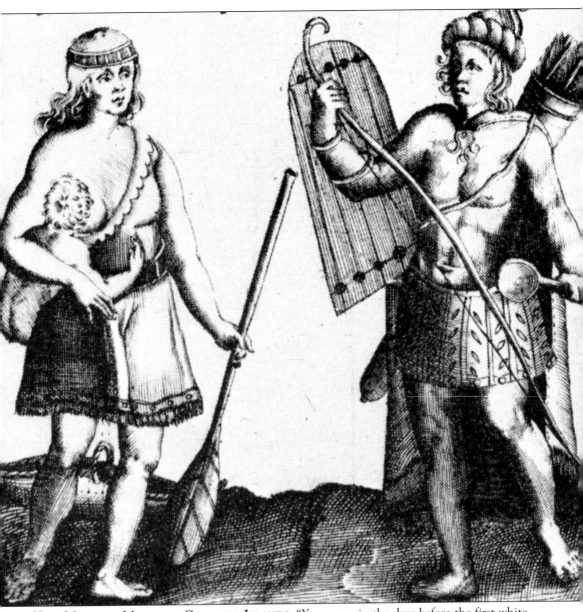

HOW MAUSHOP MADE THE CAPE AND ISLANDS. "Years ago, in the days before the first white people came across the sea, a young giant named Maushop lived in the Narrow Land . . . Sometimes he lay on one part of the Cape, sometimes on another . . . In summer he could not sleep when the heat of the land grew oppressive. On such nights he made a bed of the lower Cape; of the cool lands that lie narrowly between ocean and bay. There his body twisted and turned, changing position, seeking repose, until he shifted the level sand into dunes and hollows . . . He flung himself about, till his moccasins unfastened themselves and burrowed into the ground . . . Maushop awoke, missed his moccasins, and felt about for them. He found them and holding them tightly he raised his arm and flung the sand from them far to the south. This sand became the South Sea Islands, Nantucket and Martha's Vineyard." (Elizabeth Reynard, *The Narrow Land*, Boston: Houghton Mifflin, 1934, page 26. Illustration: 17th-century print of Indians of the Northeast.)

11

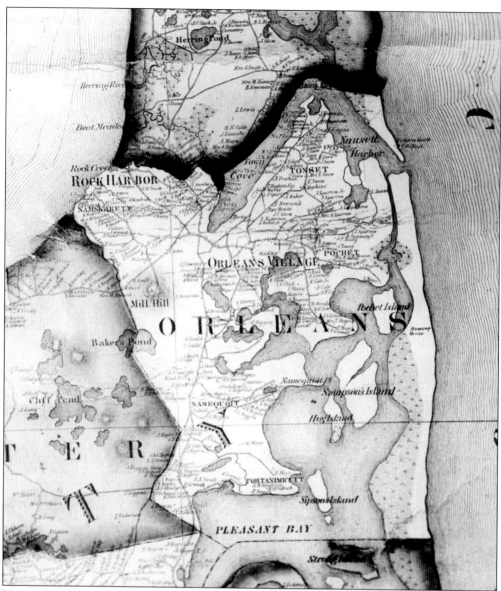

HENRY WALLING MAP, 1858, SHOWING PAU WAH POND, NAMEQUOIT, AND THE ISLANDS.
"Pau Wah, chief of the Potonamequoits, erected his wigwam at Namequoit [South Orleans]. . . .
Winter moved its stiff finger over the Narrow Land. Game was scarce and ponds were thickly
coated. . . . Pau Wah took his tent of skins, his dog, his bow, his quiver of arrows, and his fishing
tackle, and went to the pond near Namequoit, where he knew there was abundance of fish. . . .
Without asking the permission of the Water-being, he put down his fish lines and drew up a
fish. The Water Sachem, as every man knows, is short of temper, and quick to act. . . . Indian
chief, dog, tent, bow, arrows, and fishing tackle went to the bottom of that ice-coated pond.
Pau Wah has never again been seen in the land of the Nausets. . . . He has set up housekeeping
down there, and the only desires that he cannot fulfill are his love for the daughter of Chief
Quansett, and his longing for tobacco in his pipe. . . . If you want fish from its waters, carry with
you a supply of tobacco." (Elizabeth Reynard, *The Narrow Land*, Boston: Houghton Mifflin,
1934, pages 54–56.)

12

THE VIKINGS. Some interpret early Scandinavian manuscripts as proof that explorers made their way from Norway to Cape Cod. It is said that Thorwald, son of Eric the Red, visited the Isle of Nauset in 1003 and called it Furdustrandir, which means "the Wonderlands." The Isle of Nauset, now vanished, was beyond the present Nauset Harbor of Orleans.

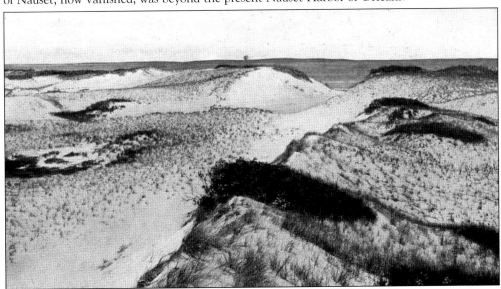

THE DEATH OF MAUSHOP. "One day a great canoe with sails . . . dropped anchor. It was named the *Mayflower*. . . . Maushop decided these were a friendly people and did not molest them. Many years later when he saw . . . his own people driven to the strange lands of the West he fell ill. A small group of white men fed an Indian some firewater and when he was very drunk learned the secret of Maushop's weakness. Going to his lodge they found him asleep and pelted him with the blue cones of the fir tree until he was dead." (*Sand in Their Shoes: A Cape Cod Reader*, Boston: Houghton Mifflin, 1951, page 40.)

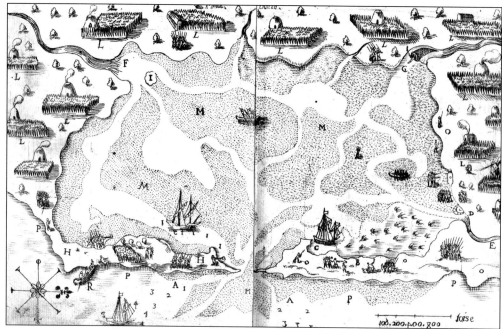

CHAMPLAIN'S MAP OF NAUSET HARBOR, JULY 1605. Wampanoag Indians lived throughout much of Cape Cod. Among them were smaller tribes, such as the Nausets, who inhabited the land in and around Orleans. French explorer Samuel de Champlain sailed into Nauset Harbor in 1605. The map he drew shows some of the 20 to 30 Nauset families in their summer camps along the shore.

CHAMPLAIN'S SELF-PORTRAIT. A friendly visit between the Nausets and Champlain's men ended badly. The men opened fire on the Nausets as one ran off with a sailor's copper pot. The sailor was killed, and Champlain captured one of the Native Americans. Later, the Nausets apologized and Champlain released the captive. Capt. John Smith's 1614 expedition created a permanent split between the two cultures. His man, Capt. Thomas Hunt, seized 24 Native Americans and sold them into slavery in Spain. Among them was Squanto.

THE PILGRIMS TURN BACK AT TUCKER'S TERROR. In November 1620, the *Mayflower* nearly foundered in the shoals off what is now Orleans. Capt. Christopher Jones attempted to take the Pilgrims to the Hudson River area, the probable site of their patent, but could not get farther than the dangerous shoals and breakers near Orleans. Tucker's Terror, today known as Pollock Rip, caused Jones to turn the ship around and seek calmer waters. On November 11, the ship rounded Cape Cod and entered the Bay, where the Pilgrims would later settle at Plimoth.

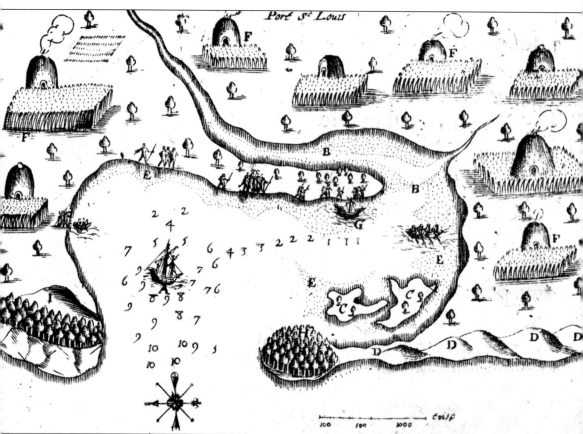

CHAMPLAIN'S DRAWING OF PLIMOTH HARBOR, 1613. In July 1621, young John Billington disappeared from Plimoth Plantation. Gov. William Bradford sent Myles Standish and Squanto to find the boy, and they sailed their shallop through a squall in the bay. The Cummaquid Indians told them the boy was in the custody of the Nausets. *Mourt's Relation* (1623), described what happened—probably in Rock Harbor: "The savages here came very thick amongst us. . . . Aspinet [their sachem] came with a great train; and brought the boy with him, one baring him through the water. He had not less than a hundred with him; the half whereof came to the shallop side unarmed with him; the other half stood aloof with their bows and arrows. There he delivered us the boy, behung with beads; and made peace with us."

THE DEATH OF SQUANTO. In November 1622, Gov. William Bradford attempted to sail for the Virginia plantation in the *Swan* to get supplies for the starving Pilgrims. Squanto volunteered to guide the ship on the treacherous voyage. During the *Swan's* second try to negotiate Pollock Rip in the waters off of Orleans, Squanto became feverish and died suddenly. The Pilgrim fathers prayed over his soul and, it is probable, buried him in the Orleans area. This view looks toward Indian Fort Hill. (Photograph courtesy of the Orleans Historical Society.)

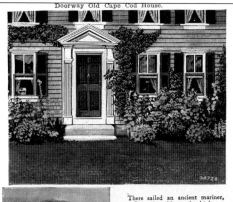

Doorway Old Cape Cod House.

A FANCIFUL VERSE POSTCARD ABOUT THE PRE-PILGRIM EXPLORERS OF THE CAPE. In 1644, the Plimoth court granted seven families from Plimoth "all the tract of land lying between sea and sea, from . . . Namskaket [Orleans] to Herring Brook at Billingsgate [South Wellfleet]." The eastern section of Orleans was later bought from Mattaquason, chief of the Monomoy tribe. Mattaquason held onto Pochet Island and Nauset Heights for shelters and cornfields. Thus, for a time, the European settlers and the Cape's Native Americans lived side-by-side in a land called Nauset.

"Old Salt," Cape Cod, Mass.

There sailed an ancient mariner,
 Bart Gosnold was he hight—
The Cape was all a wilderness
 When Gosnold hove in sight.
The hills were bold and fair to view,
 And covered o'er with trees.
Said Gosnold: "Bring a fishing line,
 While lulls the evening breeze.

"I'll christen that there sandy shore
 From the first fish I take—
Tautog or toad-fish, cusk or cod,
 Horse-mackerel or hake.
Hard-head or haddock, sculpin, squid,
 Goose-fish, pipe-fish or cunner,
No matter what, shall with its name
 Yon promontory honor."

Old Neptune heard the promise made—
 Down dove the water-god,
He drove the meaner fish away
 And hooked the mammoth cod.
Quick Gosnold hauled, "Cape-Cape-Cape Cod!"
 "Cape Cod!" the crew cried louder,
"Here steward take the fish away,
 And give the boys a chowder."

17

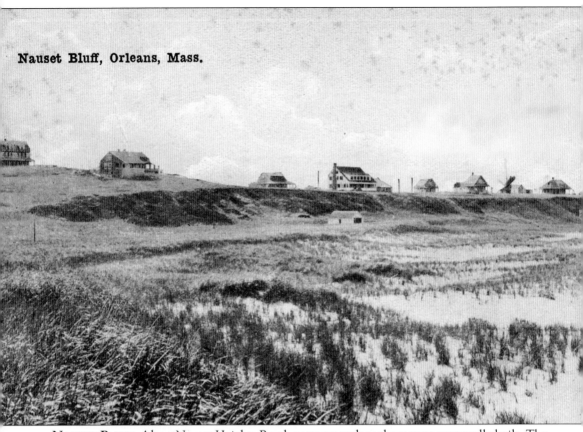

Nauset Bluff, Orleans, Mass.

NAUSET BLUFF. Along Nauset Heights Road, cottages such as these were eventually built. The Nausets had occupied this and several other sections of town. In 1672, the Reverend Samuel Treat was called to the area as minister. He devised a written form of the Nauset language and passionately taught the Native Americans Christianity. At Potanumaquut, now South Orleans, the Native Americans then (in 1682) set up their own court and magistracy. The last known Native Americans to survive in Orleans—Dorcas Hammond, age 92, and Ruth Ned, age 95—were alive in 1863. (Postcard courtesy of Mr. and Mrs. Stanley Snow.)

Two

HARBORS, BAYS, COVES, AND THE SEA

Town Cove, a harbor for small craft, extends from Nauset Harbor southwesterly . . . forming one of the most beautiful sheets of water in the town . . . The sloping banks of Pleasant Bay, in which, and in its tributaries and coves, the best of fishing abounds . . . render the territory a conspicuous site for pleasure seekers.
—Simeon L. Deyo, 1890.

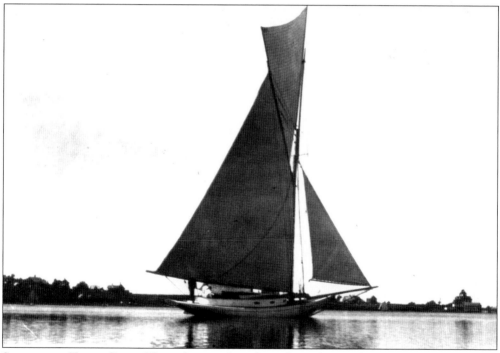

SAILING ON TOWN COVE. This calm cove has always been the jewel of Orleans. It was here at the head of Town Cove that the settlers from Plimoth built their first meetinghouse in 1646. Used for both worship and defense, the thatched-roofed structure had portholes large enough only to accommodate the firing of muskets. (Photograph courtesy of Mr. and Mrs. Stanley Snow.)

TOWN COVE, TONSET, AND NAUSET HEIGHTS. On April 1, 1644, Thomas Prence, a former governor of Plimoth, set up the first shelter of the settlers in Nauset. He had led seven families, made up of 49 people, from the mother church in Plimoth to the "Second Pilgrim Settlement," as town records called it. This land—now comprised of Orleans, Eastham, and South Wellfleet—retained its Native American name until 1651, when it was granted the name Eastham. (Photograph courtesy of Michael Parlante.)

A Panorama of Pleasant Bay, Nearly 300 Years after the Firstcomers Arrived. In 1644, the heads of the seven families of firstcomers were Thomas Prence (governor of Plimoth Colony, 1634, 1638, 1655–1673), John Doane (arrived at Plimoth, 1630, made church deacon, 1633), Nicholas Snow (came to Plimoth, 1623, married Constance Hopkins, who had arrived on the *Mayflower*), Josiah Cook (son of Francis Cook, who had arrived on the *Mayflower*), Richard Higgins (a tailor from England, by way of Salem and Plimoth), John Smalley (came to New England, 1631), and Edward Bangs (came to Plimoth on the *Anne*, 1623). These surnames are still common on the Cape. (Photograph courtesy of Michael Parlante.)

A Postcard of East Orleans. "The face of the town is quite uneven, but contains no high hills. Its landscape, diversified with uplands, vales, small bodies of water and numerous inlets of the sea, presents a pleasing appearance. The necks of land between the coves are fertile, and nearly the entire town is under cultivation, yielding corn, rye, vegetables and large quantities of English hay." (Simeon L. Deyo, *History of Barnstable County*, 1890, page 749. Postcard courtesy of Mr. and Mrs. Stanley Snow.)

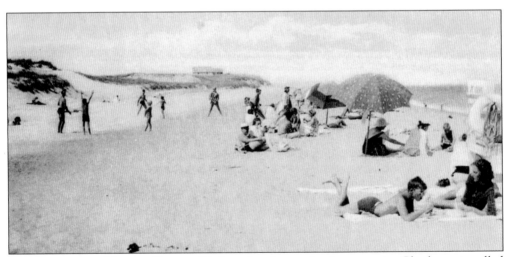

A Postcard of Nauset Beach. "A long beach terminating opposite Chatham, is called Nauset Beach. This beach is skirted inside with salt marsh. . . . The islands within Pleasant Bay add beauty to the scenery, and of these Pochet, east of Barley Creek, is the largest. Sampson's, southwest of the latter contains thirty acres and much good land. South of this is Hog Island, of ten acres, and southerly of this is Sipson's of twenty acres." (Simeon L. Deyo, *History of Barnstable County*, 1890, page 749. Postcard courtesy of Mr. and Mrs. Stanley Snow.)

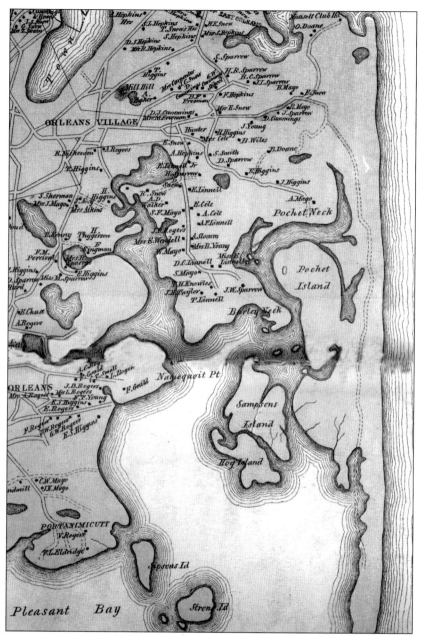

THE ISLANDS OF ORLEANS, *1880 ATLAS OF BARNSTABLE COUNTY.* "Besides Pleasant Bay and its anchorage, the town has Nauset Harbor on the northeast, containing several islands, the largest of which is Stone Island. Town Cove, a harbor for small craft, extends from the last-mentioned harbor southwesterly into the town, forming one of the most beautiful sheets of water in the town. . . . Namequoit Neck has Higgins' River on the north, and a creek of the same name as the neck on the south. Potanumaquut is the Indian name of the south part of the town. Namskaket Creek is in part the dividing line from Brewster, and forms a small harbor. There are salt marshes fringing all these harbors, bays, creeks, and even the islands. These shores and coves are productive in shellfish, sea clam, bass, tautog, and eels." (Simeon L. Deyo, *History of Barnstable County*, 1890, pages 749–750.)

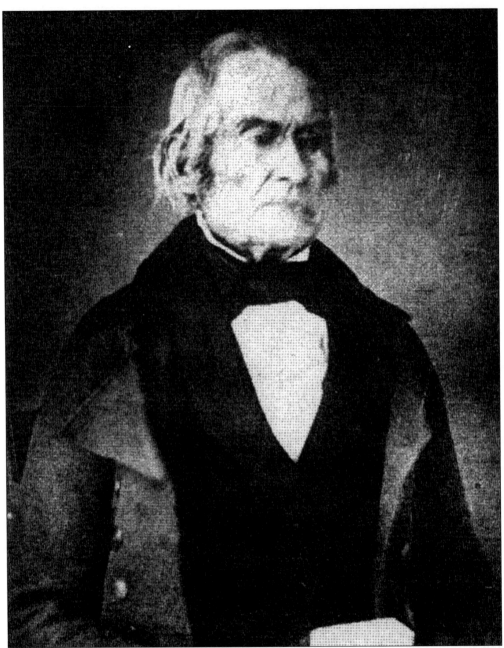

ISAAC SNOW AND THE TOWN NAME. The name Orleans was suggested by Isaac Snow in 1797, when the parish separated from Eastham. He, like others on the committee appointed to choose a name, had fought in the Revolutionary War. Having been captured twice and taken to Gibraltar and England, he was given up for lost. After one daring escape, Snow made his way to France. There, he met the Marquis de Lafayette and Count d'Estaing, and he returned to America as a crew member of their fleet. In gratitude for the help of the French in the Revolution and the help of the French to him personally, Snow suggested his town be named Orleans, after the French hero Louis Philippe Joseph, duc d'Orleans. (Photograph courtesy of the Orleans Historical Society.)

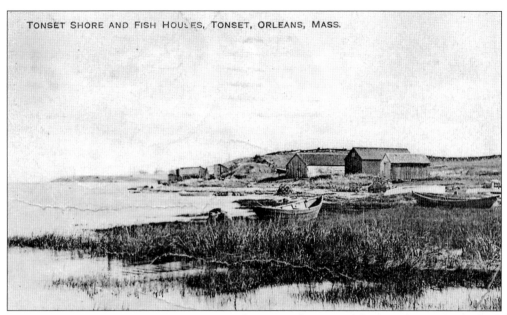

TONSET SHORE AT TOWN COVE. In 1797, the town's first pound for stray livestock was built on land north of the Simeon Higgins place at Tonset. The first poorhouse was built in 1831, on Pochet Neck, east of Town Cove. A new one was located behind the Methodist church in 1873. Meanwhile, the pound was moved about and, by 1890, was located near the town poorhouse, seemingly gathering stray animals and stray people together. (Postcard courtesy of Mr. and Mrs. Stanley Snow.)

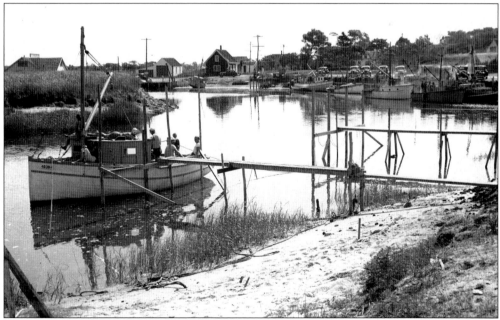

ROCK HARBOR. The area at Rock Harbor was held as common land of the proprietors. In 1814, the town built a landing there and a road connecting the harbor to the town. At that time, packet ships transported goods between Orleans and Boston. Thus, for many years the town's shipping business was centered at Rock Harbor. (Photograph courtesy of Michael Parlante.)

25

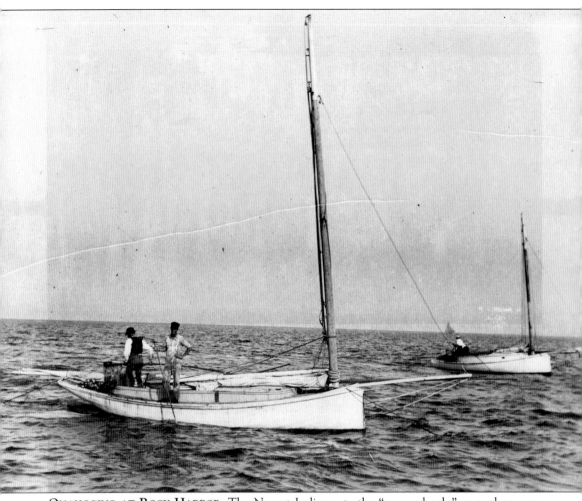

QUAHOGING AT ROCK HARBOR. The Nauset Indians ate the "poquauhock," or quahog, raw, boiled, steamed, or roasted. From the purple shell layers of the oldest quahogs, they made wampum. By the beginning of the 20th century, hand raking for quahogs at Rock Harbor was a profitable business. Quahogs, also known as hard-shell or round clams, grow at or just below the saltwater tidal flats. Men would take their 28-foot quahoging boats out to the Crick, as they called Rock Harbor. In 10 to 40 feet of water they would anchor their boats fore and aft and lower their rakes to the bottom. (Photograph courtesy of Mr. and Mrs. Stanley Snow.)

BULL RAKING FOR QUAHOGS. "So, with everything secure, we would be on our way to the Channel for a long day of raking. It took the *Ella B.* with her two-cylinder, 4-cycle Peerless engine about 35 minutes to make the run. Many's the half hour snooze I have enjoyed, comfortably cushioned on a pile of burlap bags, lulled to sleep by the rhythmic 'Ka-pow, Ka-pow' of the engine, rocked by the lift of the waves and warmed by the rising sun, while Dad set course for the Channel. . . . One of the most beautiful sights I can imagine is that of a quahog boat anchored in the distance with the quahoger pulling up his rake . . . the graceful smooth curve of his well made 56-foot pole arching across the boat just before the tee touched the water 20 or more feet away." (Warren S. Darling, *Quahoging out of Rock Harbor, 1890–1930*, Orleans, 1984. Photograph courtesy of Mr. and Mrs. Stanley Snow.)

EBENEZER CUMMINGS QUAHOGING IN ROCK HARBOR. A load of quahogs, stones, old shells, snails, and seaweed is hauled aboard Ebenezer Cummings's boat. Ebenezer Cummings, the brother of photographer Henry K. Cummings, is about to dump the load on the stern deck for culling. (Photograph courtesy of Mr. and Mrs. Stanley Snow.)

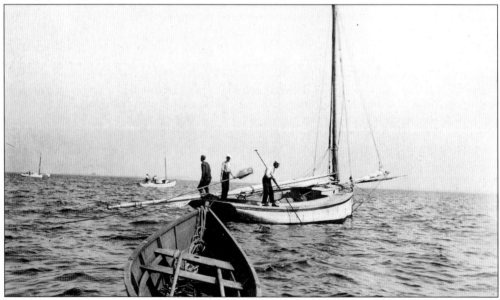

TWO QUAHOGERS AND A CULLER. These three men, one of whom was Allen Nickerson, are quahoging on a catboat at Rock Harbor *c.* 1902. (Photograph courtesy of Mr. and Mrs. Stanley Snow.)

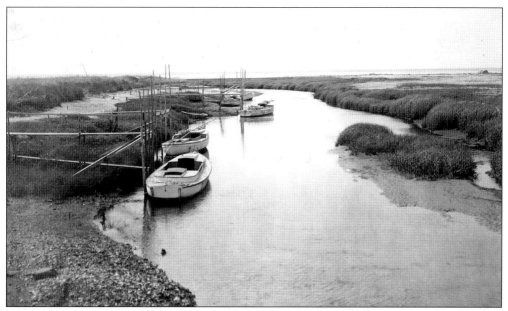

ROCK HARBOR, 1929. "After a day of setting anchors, raking, culling, holding turn, changing poles as the depth of water changed, slacking off, and resetting the anchors in new positions, it would be time to up-anchor and head for the Crick." (Warren S. Darling, *Quahoging out of Rock Harbor, 1890–1930*, Orleans, 1984. Photograph courtesy of Michael Parlante.)

ROCK HARBOR, 1920s. In a vain attempt to reshape land and sea, a dam was built across Namskaket Creek at Rock Harbor in 1833. The dam would retain the water, which (it was thought) would deepen the shipping channel by allowing the water to escape at low tide. After an enormous expenditure of $2,000, the dam was abandoned. (Photograph courtesy of Michael Parlante.)

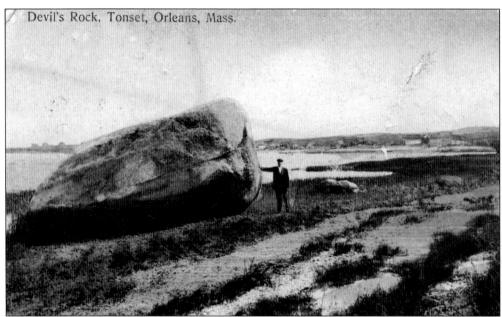

Devil's Rock, Tonset, Orleans, Mass.

DEVIL'S ROCK, TONSET. The great mass of Cape Cod was formed primarily by the Wisconsin Stage Glacier, a 10,000-foot wall of ice that advanced from the north 25,000 years ago. The glacier approached and withdrew several times over the centuries, forming and reforming the great arm of the Cape and Islands. After plowing up rock and sand from the seafloor, it deposited large chunks of ice and unusual erratics, huge isolated boulders like Devil's Rock, on the shores of Tonset. (Postcard courtesy of Mr. and Mrs. Stanley Snow.)

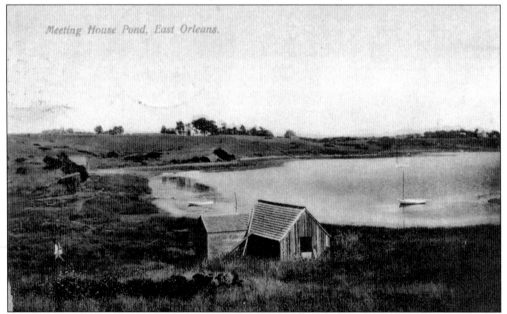

Meeting House Pond, East Orleans.

MEETINGHOUSE POND, EAST ORLEANS. The glacier formed kettle ponds and ponds such as this one, which feeds into Little Pleasant Bay. The Congregational parsonage was close to the north end of the pond, and the meetinghouse was not far to the west. (Postcard courtesy of Mr. and Mrs. Stanley Snow.)

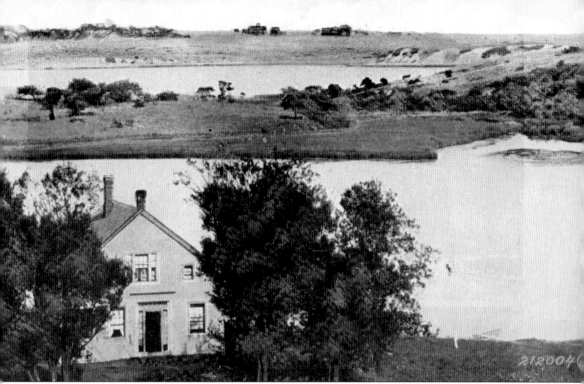

KESCAYOGANSETT POND. This pond has traditionally marked the beginning of South Orleans, which was part of the Native American community called Potanumaquut or Portanimicutt. (Postcard courtesy of Mr. and Mrs. Stanley Snow.)

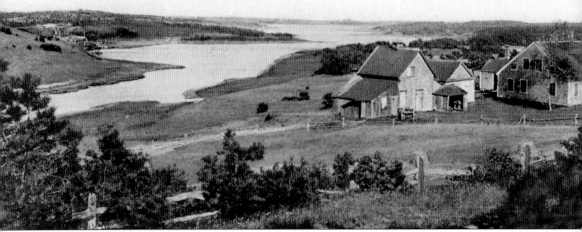

PORTANIMICUTT RIVER, SOUTH ORLEANS. Many Native American names are still current in Orleans. In the 19th century, Simeon Deyo reported: "There are yet extant in the soil the mementos of this unfortunate race, and the residents often find them. John Kenrick and Freeman Sparrow each has a fine collection of arrows, hatchets, pestles and other stone implements found here." (Postcard courtesy of Mr. and Mrs. Stanley Snow.)

Three

VILLAGE LIFE
BY THE SEA

In the early years Orleans was dotted with small villages: Rock Harbor, Skaket, Barley Neck,
Pochet, Weesit, Tonset, South Orleans . . . If we wished to go to town, we hired "Old Safety"
and the buggy. It took three quarters of an hour to go the three miles into the center.
 —Ruth L. Barnard, *The History of Early Orleans*, 1975.

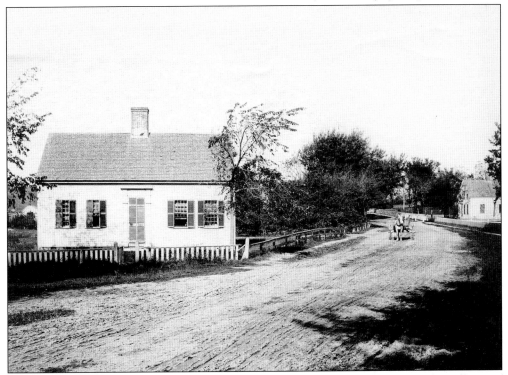

THE SALLY GOULD HOUSE, MAIN STREET. The winding roads that connect the villages of
Orleans still retain extraordinary charm. Sally Gould was the daughter of Joshua Crosby, the
famed gunner on the U.S. frigate *Constitution* in the War of 1812. This house still graces Main
Street, just east of the center of town. (Photograph courtesy of Mr. and Mrs. Stanley Snow.)

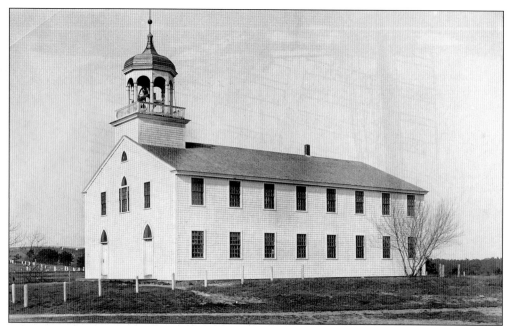

The Congregational Meetinghouse, Main Street, 1880. The first church on Orleans land was built in 1718, when the area was designated the South Parish of Eastham. Rev. Samuel Osborne, the first minister there, was replaced in 1739. In 1804, the meetinghouse itself was replaced by a larger building. In 1805, a singing master was hired and, in 1810, the town bought a bass viol as the church's only instrument. Later, the building was taken down, and the one shown was built in 1829. (Photograph courtesy of Mr. and Mrs. Stanley Snow.)

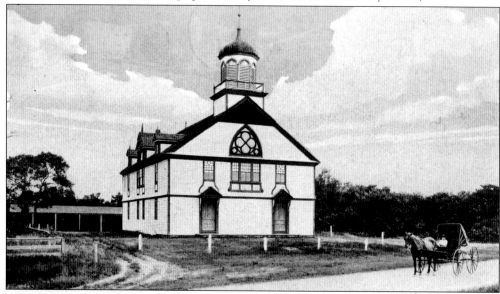

A Postcard of the Congregational Church, Main Street. In 1834, a split occurred in the church. The dissenters built the Universalist Society meetinghouse, in which the Orleans Historical Society now resides, on the other side of Main Street. The old Congregational church, now the Federated church, was renovated and rededicated in 1888. In 1933, a merger healed the original 1834 division. (Postcard courtesy of Mr. and Mrs. Stanley Snow.)

THE METHODIST CHURCH ON THE RIGHT, MAIN STREET, ACROSS FROM THE OLD SNOW LIBRARY. In 1820, when town and church separated (the town ceased paying the Congregational minister's salary), the first Methodist meetinghouse was built in the town center. The present Methodist church originated in 1836, after which time Methodism rapidly increased. The great Methodist Church revivals of 1842 and 1843 inspired thousands to travel to the Cape for camp meetings throughout the century. (Photograph courtesy of Mr. and Mrs. Stanley Snow.)

A BOY TENDING HORSES. This young boy steadies the horses of the Methodist camp meeting barge called the *Vigilant*. On August 30, 1871, Orleans native David Snow wrote, "At Yarmouth we had a goodly number converted; among them was a man seventy years old, father of one of the preachers, who got fully saved at the same time." (Photograph courtesy of John Bosko.)

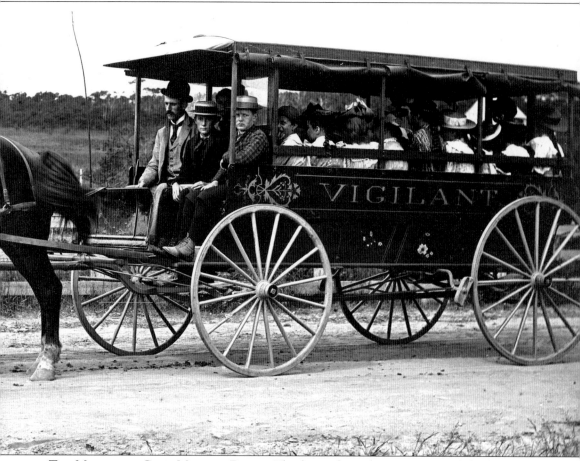

THE METHODIST CAMP MEETING BARGE. This horse-drawn barge transported children to the large Methodist gatherings. Henry David Thoreau described the camp meeting fervor: "Hysteric fits are very common in Orleans, Eastham and towns below, particularly on Sunday, in the times of divine service. When one woman is affected, five or six others generally sympathize with her; and the congregation is thrown into the utmost confusion . . . a large portion of the population are women whose husbands are either abroad on the sea or else drowned, and there is nobody but they and the ministers left behind." (*Cape Cod*, 1865. Photograph courtesy of John Bosko.)

THE METHODIST CEMETERY, MAIN STREET. The original Methodist church had been near the crossroads at the very center of town. The church's little cemetery remains a peaceful landmark in the midst of busy, modern Orleans. (Photograph courtesy of Mr. and Mrs. Stanley Snow.)

SNOW'S BLOCK AT THE CROSSROADS. Charles Parker waters his horse, and William H. Snow is in the wagon, on the right. In 1885, Capt. Aaron Snow built Snow's Block just beyond the Methodist Cemetery. By the juncture of Main Street and the County Road (Route 6A), it held meeting rooms, a gymnasium, a theater, an enclosed shooting gallery, and a livery stable. For many years the social center of Orleans, Snow's Block was taken down in the 1930s. (Photograph courtesy of Mr. and Mrs. Stanley Snow.)

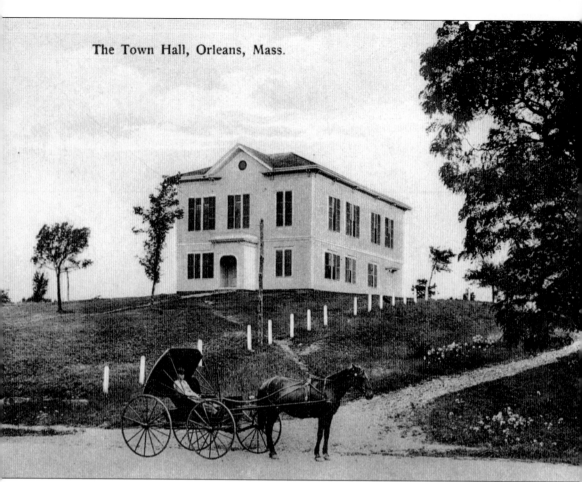

The Town Hall, Orleans, Mass.

THE ORLEANS TOWN HALL OF 1873. Many died in the smallpox epidemic of 1816, but the population continued to rise, reaching 1,348 in 1820. Methodists, Universalists, and Baptists rivaled the primacy of the Congregational Church. With the old meetinghouse no longer appropriate for a government separated from the church, the first town hall was built in 1837 near the gate of the Main Street cemetery. It was replaced by a substantial new building in 1873, which still stands opposite the Civil War soldiers monument, a bit closer to the town center. (Postcard courtesy of Mr. and Mrs. Stanley Snow.)

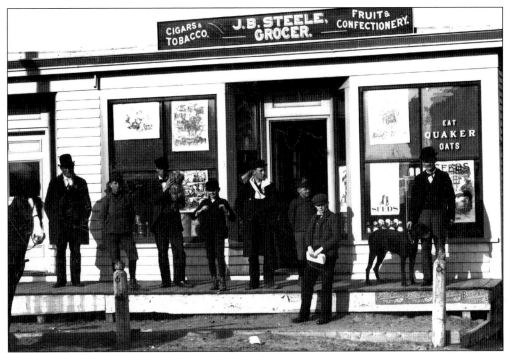

THE J.B. STEELE GROCERY STORE, MAIN STREET. This busy shop next to Snow's Store carried cigars, Battle Ax Plug Tobacco, fruit, candies, seeds, Quaker Oats, and Nutrio Tone feed for horses. It was torn down in 1971. (Photograph courtesy of John Bosko.)

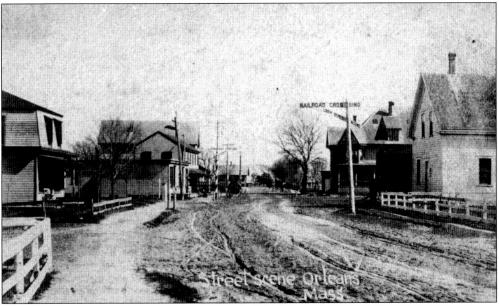

MAIN STREET, FROM THE ROCK HARBOR SIDE. William H. Snow and his wife, Annie Snow, lived in the house on the far left. When his father, Capt. Aaron Snow, became elderly and gave up the family hardware business, William H. Snow moved the store into this house. The nearby railroad station, whose tracks crossed by the store, made the shipping of paint, nails, tools, and household goods convenient. (Postcard courtesy of Mr. and Mrs. Stanley Snow.)

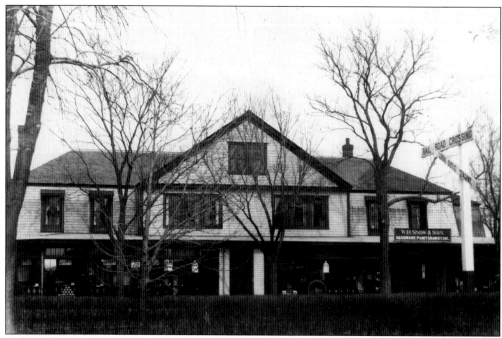

SNOW'S STORE, MAIN STREET. William H. Snow's mansard-roofed house and store became the ell of this much enlarged hardware business in 1922. (Photograph courtesy of Mr. and Mrs. Stanley Snow.)

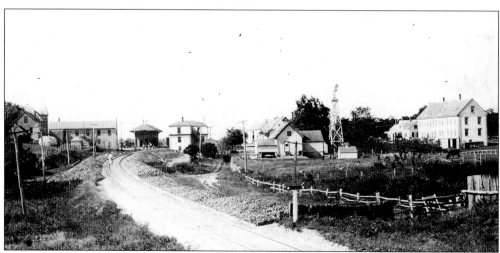

MAIN STREET, FROM THE NORTH, 1880s. This unusual view from the railroad tracks shows the back of Higgins Block on the left, the railroad station, T.A. Smith's Grocery Store, W.H. Snow's Hardware Store, and Snow's windmill. On the far right is George Snow's Pants Factory, which employed 25 to 35 workers by 1890. (Photograph courtesy of Mr. and Mrs. Stanley Snow.)

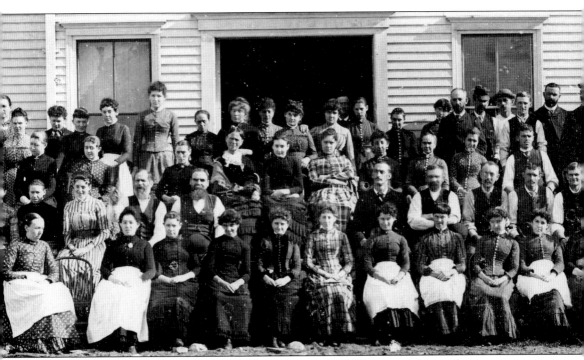

CUMMINGS & HOWES PANTS FACTORY WORKERS, C. 1886. The town's largest factory was on the corner of Main Street and Route 6A. By 1890, this steam-powered factory employed 125 to 200 people and ran 100 to 125 sewing machines. Joseph H. Cummings and William H. Howes began making shirts, overalls, and pants in a store near Cedar Pond in 1873. After a move to Canal Road, near the rotary, the factory moved to the pictured site. After 1888, the factory concentrated just on pants and shipped them all over the country. (Photograph courtesy of Mr. and Mrs. Stanley Snow.)

MAIN STREET, LOOKING EAST, 1920s. George Snow's Pants Factory is on the far left, next to W.H. Snow's Store. Beyond are the Higgins Block and the Besse Building, in an area still lined with shops. (Photograph courtesy of Mr. and Mrs. Stanley Snow.)

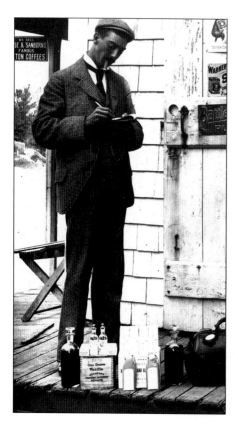

BURNETT'S FLAVORING EXTRACT SALESMAN. With bottles of vanilla extract at his feet, this salesman marks an order in his book at the Joel Sparrow Variety Store. (Photograph courtesy of John Bosko.)

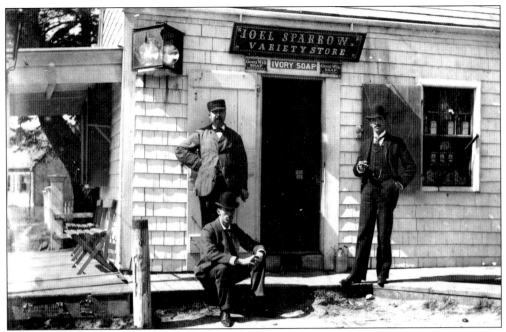

THE JOEL SPARROW VARIETY STORE. For many years, the Sparrows had a store near Cedar Pond, on the corner of Main Street and Locust Road. Brothers Jonathan and Richard Sparrow had moved from Plimoth to Eastham (which included Orleans) in 1655. Among their descendants were Dean Sparrow, who was a traveling salesman in the 1850s, and Joel H. Sparrow, proprietor of Sparrow's Variety Store. (Photograph courtesy of John Bosko.)

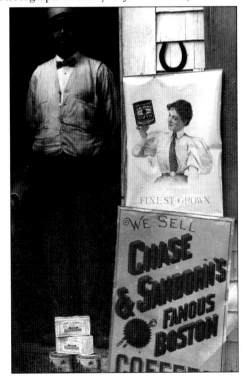

JOEL SPARROW IN THE DOORWAY OF HIS STORE. It is likely that Joel Sparrow himself is seen here, by the signs for Seal Brand Java Mocha Coffee and Chase and Sanborn's Famous Boston Coffees. Examples are seen at his feet in boxes and tins. On the right is a horseshoe on the wall, pointed up to catch good luck. (Photograph courtesy of John Bosko.)

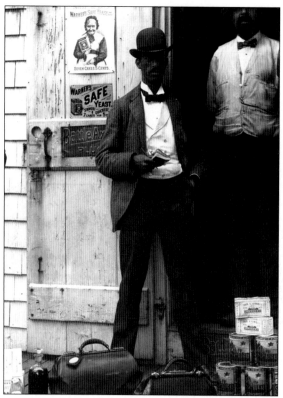

A CHASE AND SANBORN TRAVELING COFFEE SALESMAN AT JOEL SPARROW'S VARIETY STORE. This salesman displays his wares before the store's proprietor. Other products advertised on the walls of the store include Warner's Safe Yeast, Battle Ax Plug Tobacco, Ivory Soap, Good Will Soap, Pearline, Dunham's Coconut, and Pippin Apples. (Photograph courtesy of John Bosko.)

THE DAVID AND CHASE APOTHECARY SHOP, MAIN STREET. Healthcare in the mid-19th century was primitive. Doctors had no scientific knowledge of germs and viruses, and diseases such as yellow fever and diphtheria devastated entire families. Apothecary shops dispensed medicines laced with opium, morphine, and alcohol. Today, this building houses a modern, much safer descendant of the old apothecary—a health food store. (Photograph courtesy of Mr. and Mrs. Stanley Snow.)

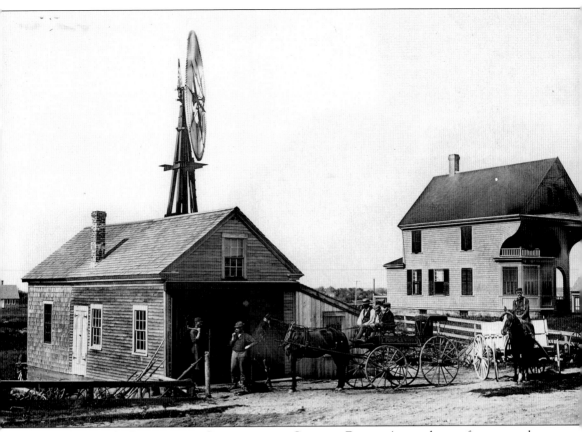

A.J. Fulcher's Blacksmith Shop on the County Road. A merchant of pump and windmill supplies pulls up to Fulcher's blacksmith shop in 1905. The distinctive house on the right is still standing on its original site (Route 6A). As with many blacksmith shops, this one converted to servicing cars after the turn of the century. To this day, a gas station remains on the same spot where horses were shod and the forge burned hot. (Photograph courtesy of Mr. and Mrs. Stanley Snow.)

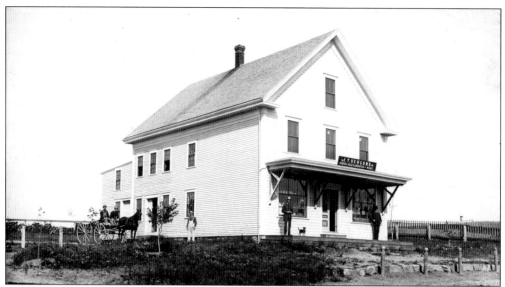

A.T. Newcomb's Hardware Store. In 1860, Thomas S. Newcomb left the sea and opened a hardware and tinware store near the northern bank of Town Cove. His son, A.T. Newcomb, bought the store and moved it across the road (Route 28) the next year. It is, even today, the site of a store selling hardware, paints, and tools, as it did in the Newcombs' day. (Photograph courtesy of Mr. and Mrs. Stanley Snow.)

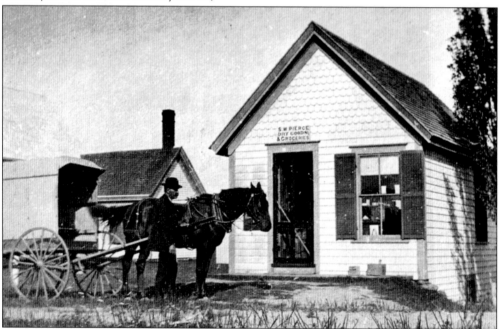

S.W. Pierce Dry Goods & Groceries, Champlain Road, 1902. Captain and Mrs. Pierce ran this store (the building still stands) in the Tonset section. The earliest known stores in Orleans appeared after 1657 on the road at the head of Town Cove. This road went toward Pochet and included parts of Route 28 and the east section of Main Street. Lot Higgins, William Myrick, Lewis Doane, and Leander Crosby had stores along the road in the 19th century. (Photograph courtesy of the Orleans Historical Society.)

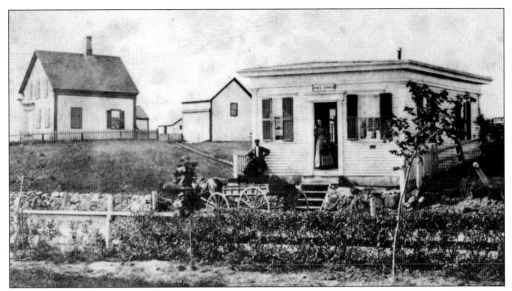

The Orleans Post Office, Main Street, next to the Methodist Church. The first mail was delivered to Orleans in the 18th century by post rider and was delivered to Simeon Higgins's tavern on the County Road (Route 6A). Simeon Kingman was appointed the first Orleans postmaster in 1800. Among those who followed were women such as Amelia Snow, who is likely the person seen in the doorway. She served from 1866 to 1885. The post office was later moved to the town center, by the Methodist cemetery. (Photograph courtesy of Mr. and Mrs. Stanley Snow.)

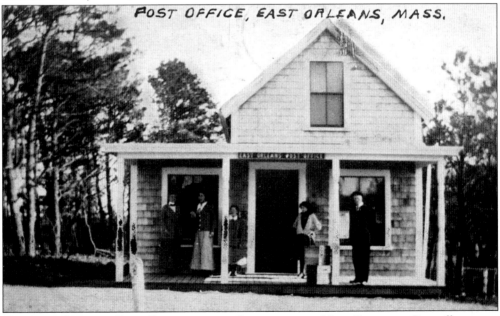

The East Orleans Post Office, at the Start of the 20th Century. Post offices were set up at East and South Orleans, sometimes in separate buildings, but often in homes and shops. Lot Higgins was appointed the first postmaster of East Orleans in 1890. He kept the post office in his store and passed both on to Sam Higgins c. 1900. (Postcard courtesy of Mr. and Mrs. Stanley Snow.)

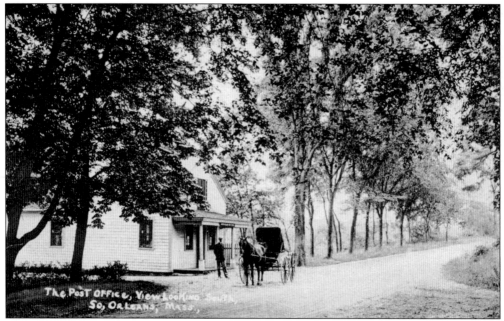

THE SOUTH ORLEANS POST OFFICE. Throughout the 19th century, from its founding in 1835, the post office of South Orleans was in various shops on what is now Route 28. Seth Sparrow was the first postmaster, followed by his son Seth Everett Sparrow in 1862. John Kenrick was appointed in 1865 and served for decades. (Postcard courtesy of Mr. and Mrs. Stanley Snow.)

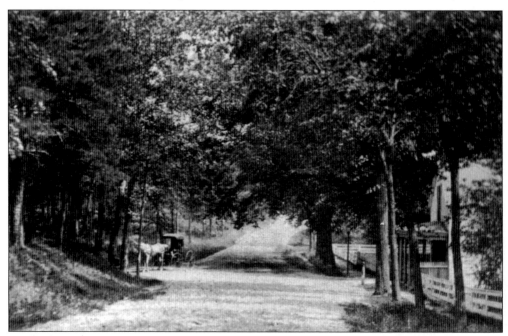

THE SOUTH ORLEANS POST OFFICE AND WATER PUMP. The same post office building, which still stands today, is seen from the opposite end of the tree-lined road. What may be the same horse and carriage is taking advantage of the town pump on the other side of the road. (Photograph courtesy of Mr. and Mrs. Stanley Snow.)

THE CHURCH OF THE HOLY SPIRIT, SOUTH ORLEANS. This Episcopal church was begun in 1933 with only 17 members. Located on Monument Road, it contains a 15th-century Della Robbia plaque and altar lace nearly three centuries old from a church in the south of England. In 1857, the *Orissa* shipwrecked in Orleans and remained buried for 37 years. Its galley deckhouse is now the "Galley West" section of the church. (Photograph courtesy of Mr. and Mrs. Stanley Snow.)

THE OLDEST HOUSE IN ORLEANS. The Lt. Prence Snow house was built in 1723 by the canal that used to cut through Orleans. Framed with oak from Eastham's original 1644 meetinghouse and fort, it was oriented to the North Star so that the sun would track the living quarters on the house's south side. The Snow family occupied the house from 1723 to 1956. (Photograph courtesy of Michael Parlante.)

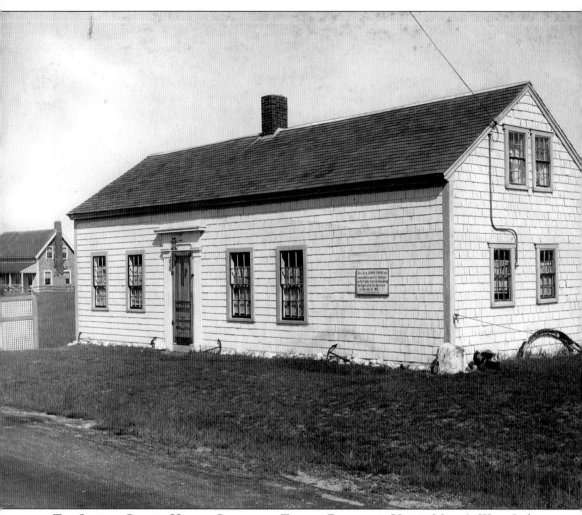

THE JOSHUA CROSBY HOUSE, CORNER OF TONSET ROAD AND UNCLE MARK'S WAY. Joshua Crosby went to sea at age 13 aboard a fishing schooner to Georges Bank. He became a gun captain on the USS *Constitution* during its famous battle with the HMS *Guerriere* in the War of 1812. Crosby was on the *Constitution* (Old Ironsides), too, when it captured the HMS *Java*. He then served under Commo. O.H. Perry on Lake Erie in the September 10, 1813 battle that changed the course of the war. He sailed on whalers and trading schooners and, at age 60, left the sea to become the lighthouse keeper of the Three Sisters at Chatham. (Photograph courtesy of Michael Parlante.)

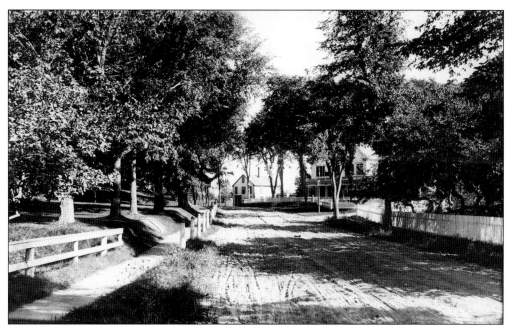

THE CALVIN SNOW HOUSE, MAIN STREET, EAST ORLEANS. Unlike Joshua Crosby and many others, Calvin Snow left Orleans for the West, rather than for the sea. After making a small fortune in meat packing in Chicago, he returned to Orleans and built this house. It was later razed to make way for the Masonic Lodge. (Photograph courtesy of Mr. and Mrs. Stanley Snow.)

THE SAMUEL SPARROW SR. HOUSE, OFF BRICK HILL ROAD. This classic Cape Cod farmstead has gone the way of many and has become part of the Ocean Harbor development. (Photograph courtesy of Mr. and Mrs. Stanley Snow.)

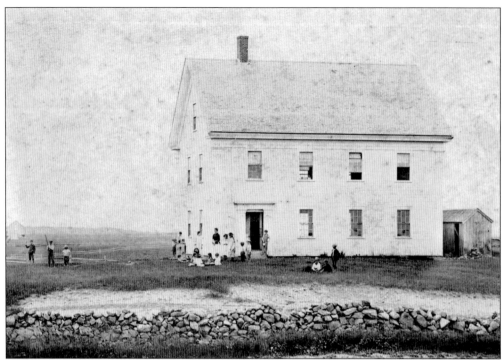

THE EAST ORLEANS PRIMARY AND GRAMMAR SCHOOL, BRICK HILL ROAD. The first school in the Nauset area was begun in 1666, with Jonathan Sparrow as schoolmaster. Until the first school buildings were constructed in 1762, the schoolmaster moved from district to district every few months. (Photograph courtesy of Mr. and Mrs. Stanley Snow.)

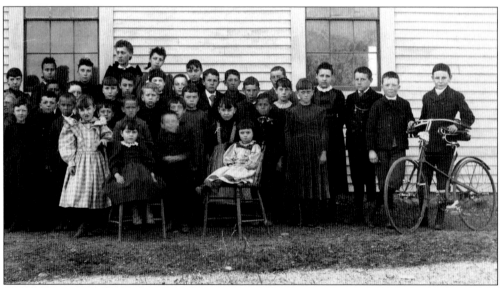

CHILDREN OF THE EAST ORLEANS PRIMARY AND GRAMMAR SCHOOL, MID-19TH CENTURY. In the earliest days, a fisheries tax on the netting, or seining, of mackerel, bass, and herring helped pay for the schools. By 1816, six school districts were set up, and several new schoolhouses were built. (Photograph courtesy of Mr. and Mrs. Stanley Snow.)

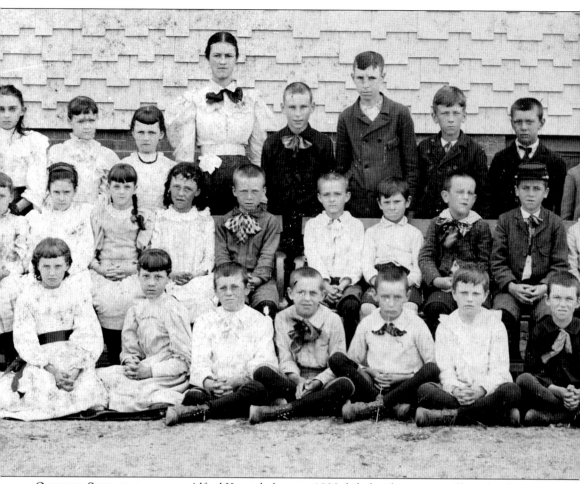

ORLEANS SCHOOLCHILDREN. Alfred Kenrick, born in 1800, left this description of his schooling: "I remember that at the age of six I was sent to a private school kept in a little porch connected with the house of Dea. Judah Rogers where I was taught by a maiden lady—the deacon's daughter. The seats were constructed of unplaned boards resting on blocks of wood . . . the teacher's wages only averaged eighty cents per week, the term seldom exceeded ten or twelve weeks. About two years later I attended the public school, having its winter term taught by a male teacher—a term usually of ten weeks." At the age of 15, Kenrick shipped aboard the schooner *Joseph* and began the seafaring life. (Photograph courtesy of Mr. and Mrs. Stanley Snow.)

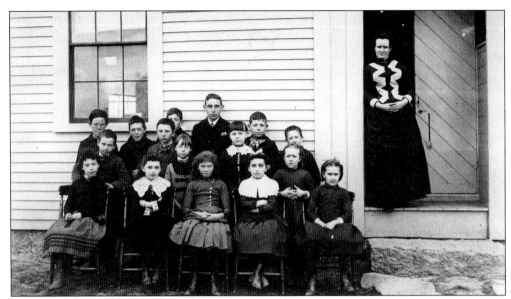

A Schoolmistress and Students, the Orleans Elementary School. Firm moral guidance was expected by teachers in the 19th century. In 1799, town meeting ruled that all teachers had to meet the approval of both municipal and ecclesiastical town leaders. (Photograph courtesy of Mr. and Mrs. Stanley Snow.)

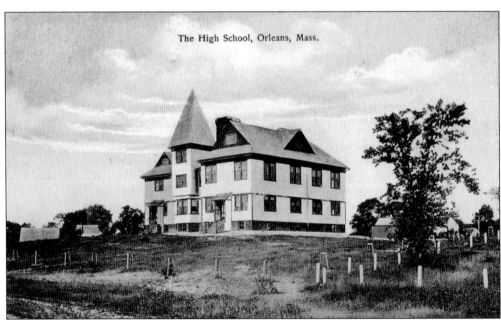

The High School, Orleans, Mass.

The Old Orleans High School, Site of the Present-day Nauset Regional Middle School, Route 28. A two-room high school was built in 1873, where the American Legion Hall is today, on School Street. By 1880, there were 10 school districts, with small schoolhouses scattered across Orleans. Schools later consolidated and, in 1939, the large high school pictured was built to serve both Eastham and Orleans. (Postcard courtesy of Mr. and Mrs. Stanley Snow.)

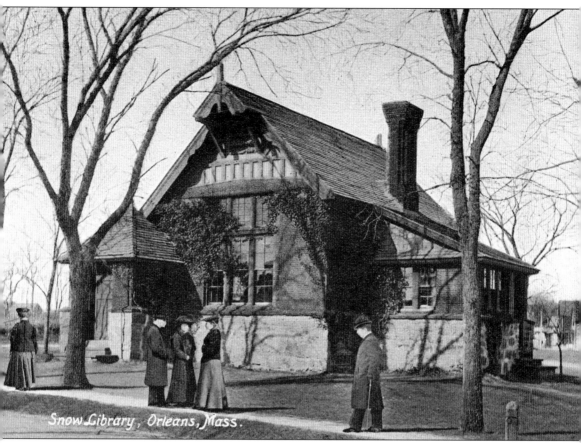

Snow Library, Orleans, Mass.

THE SNOW LIBRARY, ACADEMY SQUARE, MAIN STREET. When David Snow's father died three weeks after David's birth in 1799, the family was destitute. As a child, David dug peat, worked in gardens, and went to bed hungry. In 1875, after making a fortune in the wholesale flour, grain, and fish business in Boston, he bequeathed funds for an Orleans library. He wrote in his memoirs: "I never really felt the need of culture until I was nearly twenty years of age. . . . When I began to realize the necessity of improving my mind, I gave what spare time I could command to reading such books as came my way; but I had to grope along in the dark with no kind hand to help me." (*From Poverty to Plenty; or, The Life of David Snow, Written by Himself,* Boston, 1875. Postcard courtesy of Mr. and Mrs. Stanley Snow.)

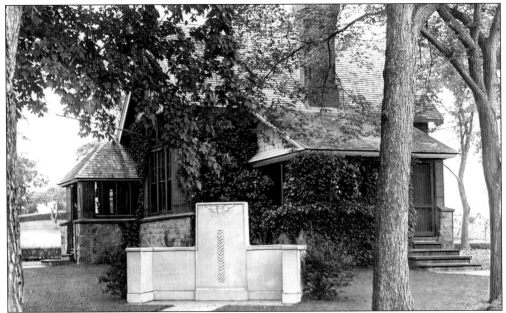

THE SNOW LIBRARY AND THE WORLD WAR I MONUMENT. This English Gothic library, made of sandstone and brick, was built in 1877. The design faced some opposition, but the library soon became a much-loved town landmark. During one of the worst blizzards in decades, it burned to the ground on February 25, 1952. The World War I monument still stands on this Academy Place location. (Photograph courtesy of Mr. and Mrs. Stanley Snow.)

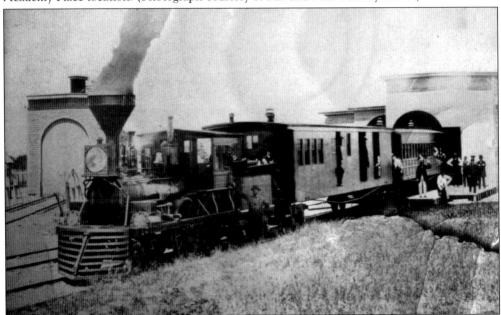

THE OLD COLONY RAILROAD. Village life in a seaside town changed forever with the coming of the railroad. In 1848, the rail line reached only as far as Sandwich and was not laid from Yarmouth to Orleans until 1865. Until then, Orleans relied on packet ships to send out its harvest from the sea or bring in off-Cape merchandise. (Photograph courtesy of Mr. and Mrs. Stanley Snow.)

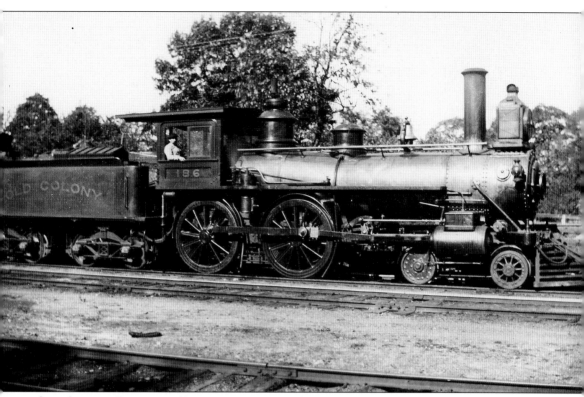

OLD COLONY RAILROAD ENGINE NO. 186. Joshua Nickerson recalled railroading days in Orleans: "They used to do a *flying switch* . . . It's when the train backs up with freight cars on it, and they disconnect one car and let it scoot down by itself onto a sidetrack and then throw the switch so the rest of the train goes onto another track. Well, they used to do that, and every now and then one of them would get out of control and coast across the street." (James S. Morse, *Snow's Store in Orleans*, H.H. Snow & Sons, 1988. Photograph courtesy of Mr. and Mrs. Stanley Snow.)

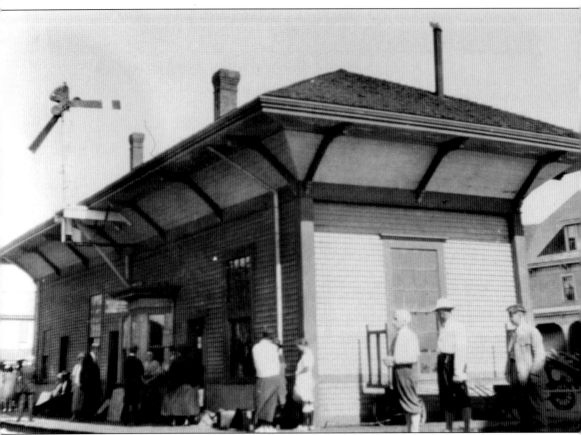

THE ORLEANS RAILROAD DEPOT, MAIN STREET. The train delivered freight to the center of Orleans, where the depot, sidings, and turntable changed the face of Main Street. Shops brought in goods more cheaply, and the pants factories had a convenient means for off-Cape shipping. Travelers no longer used the red-and-yellow stagecoach that had rambled over sandy roads, preferring the rails that opened the Cape to an age of leisure and tourism. (Photograph courtesy of Mr. and Mrs. Stanley Snow.)

Four
A GALLERY OF ORLEANS FOLKS

Gone are the old skippers. You will find a few of them in the little white houses on Cape Cod, dreaming of the old days in front of their hearths, with old dogs dreaming at their feet. Although their sailing days are over, they still live close to the sea. They like its salt breath and its voice, the surf.
—The *Times*, Orleans, December 29, 1928.

I'm sorry I don't know the feller. If I did, I'd give you a whackin' good yarn about him!
—Joseph Berger, "Orleans," *Cape Cod Pilot*, Poor Richard Associates, 1937.

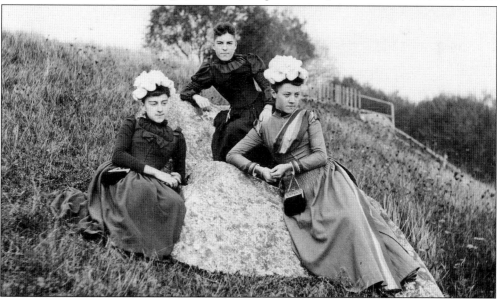

A PORTRAIT OF EVA HIGGINS, JOSIE HIGGINS, AND BERTHA TAYLOR. From the time Henry K. Cummings took up photography at the age of 18 in 1883 until his last known photographs in 1905, Orleans was his subject. Whether he photographed sailing sloops, picnics, shell fishermen, blacksmith shops, or lighthouses, Cummings brought the people in those images alive. We look into the expressive eyes of the past thanks to this master of the camera. (Photograph courtesy of Mr. and Mrs. Stanley Snow.)

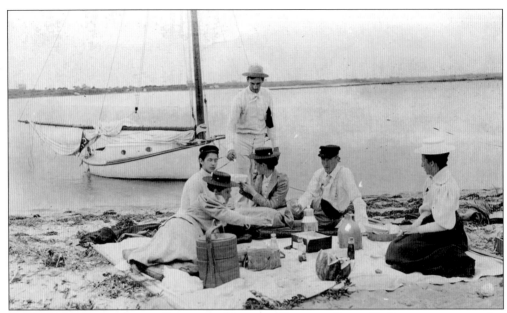

A BOATING PARTY, INNER BEACH AT NAUSET HARBOR. Henry K. Cummings set up this photograph and stood at the back of the group, with his boat behind him. Sandwiches, watermelon, and lemonade are spread before Clayton Mayo (treasurer of the Singer Sewing Machine Company), Therese Cummings (wife of photographer Henry K. Cummings), Mary S., George Snow, and Ida. (Photograph courtesy of Mr. and Mrs. Stanley Snow.)

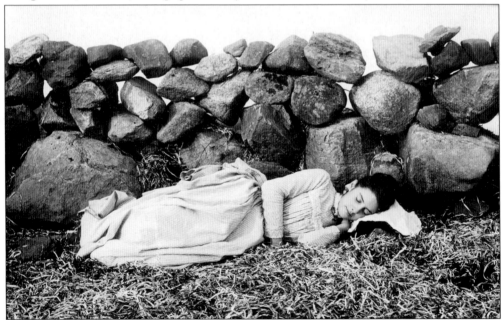

THERESE PAINE CUMMINGS. In 1887, Henry K. Cummings photographed his fiancée napping before a stone wall. Therese, daughter of Capt. Alfred Paine, went to sea as a child aboard her father's ship. On a voyage out of New York Harbor, her mother told her to get out her schoolbooks for study. Therese, after denying any knowledge of them, admitted, "I threw them all overboard as we went through the Narrows." (Photograph courtesy of Mr. and Mrs. Stanley Snow.)

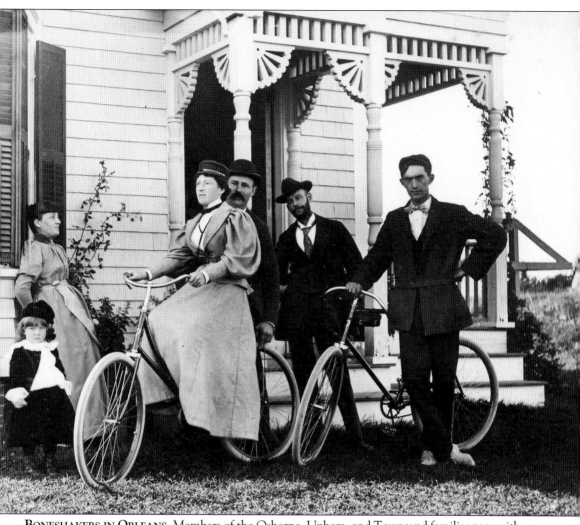

BONESHAKERS IN ORLEANS. Members of the Osborne, Upham, and Townsend families pose with new bicycles, dubbed "boneshakers." The first rotary-crank bicycles were patented in Paris in 1866. In the United States, the first Standard Columbus bicycles were made in Hartford by the Weed Sewing Machine Company in 1878. (Photograph courtesy of Mr. and Mrs. Stanley Snow.)

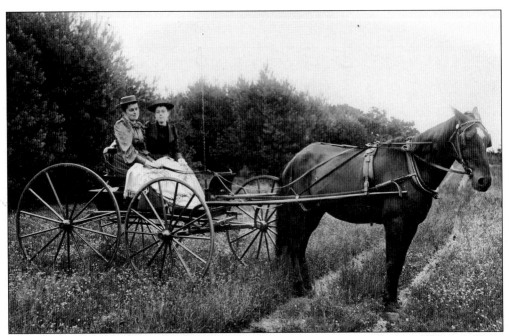

NELLIE AND GEORGIE MANCHESTER. Horse-drawn carriages continued to outperform bicycles on the Cape's sandy roads. Nellie and Georgie are pulled by their favorite horse, Coltie. (Photograph courtesy of Mr. and Mrs. Stanley Snow.)

THE ELDREDGE AND MAYO FAMILIES. Henry K. Cummings captured these members of two of the Capes earliest families, including Addie and William Eldredge and Mary Mayo. (Photograph courtesy of Mr. and Mrs. Stanley Snow.)

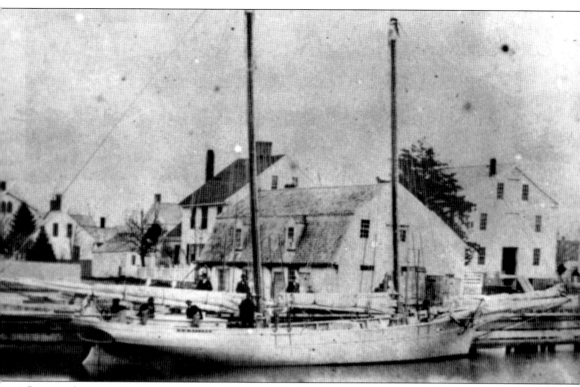

Capt. Aaron Snow's Schooner Nettie M. Rogers, Berthed in Mystic, Connecticut. The story of Orleans is intertwined with the Snow family, from Nicholas Snow's original grant of land in the center of Orleans in 1644 to the landmark Snow's Store, still on Main Street. Aaron Snow, his son William, and grandson Harry bridged the ages: Aaron Snow captained the 1870 coastal schooner *Nettie*, a floating "Snow's store," carrying coal, grain, and household goods from ports on the Eastern Seaboard to Orleans. He docked his schooner at the head of Town Cove and built the house that today is the Orleans Inn. He then built permanent stores, first on Brick Hill Road and then on the south side of Main Street. (Photograph courtesy of Mr. and Mrs. Stanley Snow.)

ANNIE LAURIE SNOW. The family schooner gave way to the railroad, which helped the Snow store—and the town itself—prosper. In 1887, Aaron Snow's son William H. Snow opened the first of the Snow stores to appear on the north side of Main Street. Goods arrived at the depot, within sight of the Snow store. The railroad also ushered in the age of summer homes and tourism. William H. Snow married Annie Laurie Walker of Harwich, who became a full partner in the burgeoning family business. (Photograph courtesy of Mr. and Mrs. Stanley Snow.)

HARRY H. SNOW. Annie and William Snow managed the Snow store as it gradually took over more of the house. Sadly, two children died in infancy before Harry H. Snow was born. The store, with the Snow's apartment above, was expanded in 1906 and was completely renovated and greatly enlarged in 1922. (Photograph courtesy of Mr. and Mrs. Stanley Snow.)

64

HARRY H. SNOW AS A YOUNG MAN. The mansard-roofed store, with orchard and gardens out back, became part of a much enlarged building. Household goods and appliances helped serve the growing summer trade. After William Snow's death in 1930, Harry H. Snow continued the business with his mother until her death in 1947, when he became sole owner. (Photograph courtesy of Mr. and Mrs. Stanley Snow.)

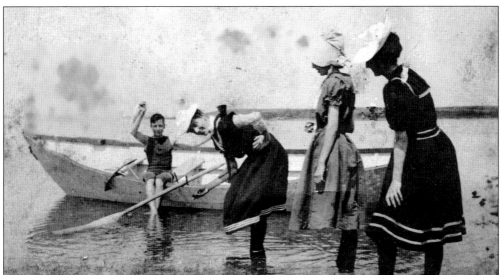

HARRY H. SNOW, 14, AND FRIENDS AT MILL POND. Harry H. Snow grew up with the Cape, the family business, and the town of Orleans in his blood. After graduation from Orleans High School in 1904, he attended Worcester Academy before returning to Orleans, where he learned his father's business, from the ground up. (Photograph courtesy of Mr. and Mrs. Stanley Snow.)

HARRY H. SNOW AND A FRIEND. Harry H. Snow served in the U.S. Army Air Corps during World War I, learning to fly cloth-covered Curtiss Jenny biplanes. He kept one hand on the rudder and one on the business back home. On November 11, 1918, Armistice Day, he wrote to his mother, "Came through part of Alabama and am in my 24th state. . . . Cancel Addie Crosby's order for wood, Harry." (Photograph courtesy of Mr. and Mrs. Stanley Snow.)

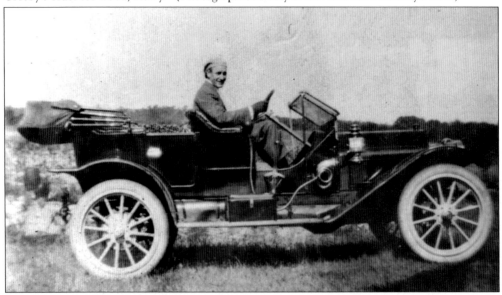

HARRY H. SNOW IN HIS TOURING CAR. After the war, Harry H. Snow returned to Orleans. He married Adeline Cullum in 1928, and the couple moved into a house across the street from the store. The modern era of Snow's began with Harry H. Snow. His distinguished building anchored the streetscape of the town center. Snow's became, and continues to be, a true general store, where neighbors meet and where virtually anything for the home and grounds can be found. (Photograph courtesy of Mr. and Mrs. Stanley Snow.)

The Home of Lucia Higgins Snow, Corner of Brewster Cross Road and Main Street. After her husband, David Snow, was lost at sea off the Bahama Banks in 1799, Lucia Higgins Snow opened a general store in her house. She sold crackers, tea, molasses, twists of tobacco, rum, and dry goods. Poverty forced her to send her two eldest children to live with relatives.

A Portrait of David Snow, Youngest Son of Lucia Snow. David Snow recalled begging his mother for food as a boy: "She stopped, went to a drawer, opened it, took out a piece of bread, and broke off a small piece and gave it me. As she did so I saw a big tear run down her cheek. That tear went to my very soul. . . . I resolved, if possible, I would seek a better condition, and escape a state of poverty." He became an owner of Constitution Wharf in Boston, of lucrative sailing ships, and of prime Boston property. He endowed the original Snow Library in Orleans, built in 1877.

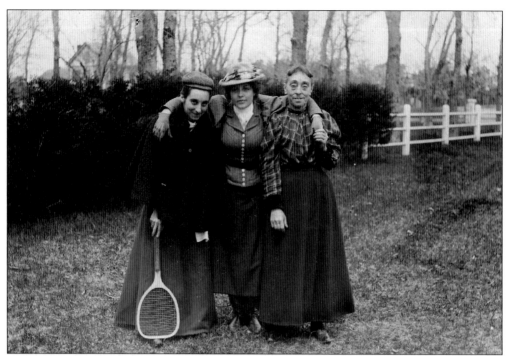

AN ENGAGING PORTRAIT BY PHOTOGRAPHER HENRY K. CUMMINGS, 1898. Pictured, from left to right, are Jessie Doane, Lizzie Doane, and R. Lemeine. (Photograph courtesy of Mr. and Mrs. Stanley Snow.)

A WINTER SCENE ON MAIN STREET. These children are being taken to school with their tin lunch pails. Main Street, before the Calvin Snow house, is covered with snow and sheets of ice. To the right is the home and shop of W.M. Crosby, "Manufacturer of Monuments, Tablets, Gravestones, Shelves, &c." (Photograph courtesy of Mr. and Mrs. Stanley Snow.)

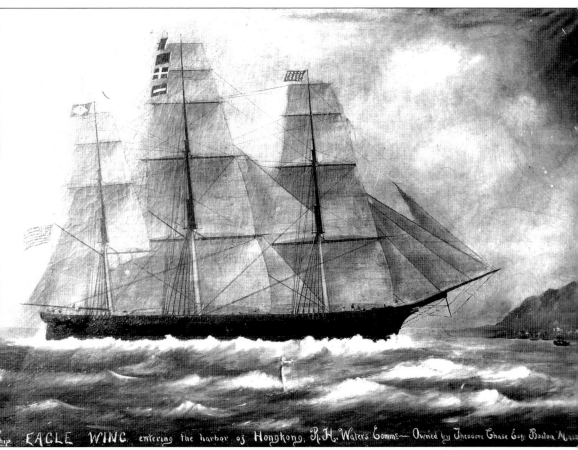

THE *EAGLE WING*, ENTERING HONG KONG HARBOR, C. 1856. Ebenezer Harding Linnell was one of the Cape's most romantic sea captains. An Orleans native, he went on voyages that took him to New Orleans, San Francisco, Calcutta, and Hong Kong. Linnell simultaneously generated great wealth and broke several speed records. The following is taken from the log of his most famous ship: "*Eagle Wing* sailed from Foo Choo Foo, July 31, 1854, laden with tea; she was at St. Helena on October 25th; and off the North Foreland, England, on December 2, 1854. . . . During the heaviest of the weather ran N.E. 38 miles, the sea hove up in grate confusion." (Photograph courtesy of the Orleans Historical Society).

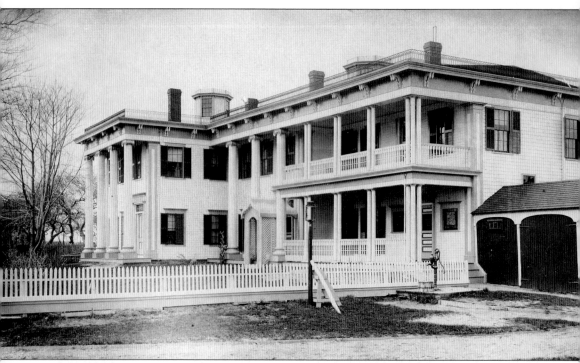

THE CAPT. EBENEZER HARDING LINNELL HOUSE, SKAKET ROAD. With his clipper-rigged ship *Eagle Wing*, Capt. Ebenezer Harding Linnell sailed from Boston on December 20, 1852, and made San Francisco on April 5, 1853, in a record run of 115 days. In ships such as the *Buena Vista* and the *Flying Mist*, Linnell carried sheep, guano, tea, and cotton between exotic ports from Glasgow to Singapore. In 1861, he took a year off from the sea to build the most imposing home in Orleans, patterned after one he had seen in Marseilles, France. The following year, the captain lost his ship *Flying Mist* on the rocks off New Zealand. Back aboard the *Eagle Wing* once again, Linnell lost his own life, tangled in the rigging during a squall off the coast of Brazil on January 4, 1863. (Photograph courtesy of Mr. and Mrs. Stanley Snow.)

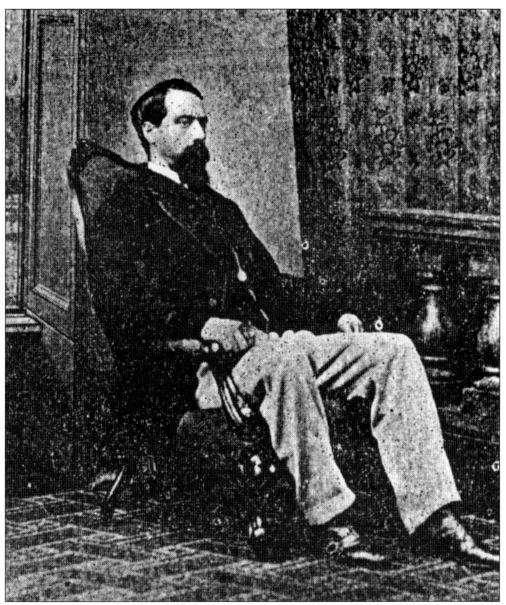

CAPT. JOSHUA N. TAYLOR, 1861. Capt. Joshua N. Taylor's memoirs of a life at sea begin early, as most do: "My first voyage at sea was on March 25th, 1850. I started out as a big fat boy of eight years and eight months to do the cooking on board the schooner *Pennsylvania*." By the time of the Civil War, Taylor was a captain himself. He sailed the *Charmer* to New Zealand and then sailed the South Seas on the yacht *Canterbury*. A drunken mate wrecked the yacht off New Zealand, close to the spot at which Capt. Ebenezer Harding Linnell lost the *Flying Mist*. In the clipper ship trade, Taylor then became master of the *Blue Jacket*, running gold from Melbourne, Australia. Joshua Taylor's memoirs recount being at the wheel of the *Sea Bird*, while in his teens, when the *Red Jacket* nearly rammed the boat: "Our captain was so mad that he could only shout and rave at him for an unwashed son of a sea dog. To cap the climax, the *Red Jacket*'s band struck up 'The Girl I Left Behind Me.' Our captain continued to rave and swear about the 'damned lime-juicer' as long as she was in sight."

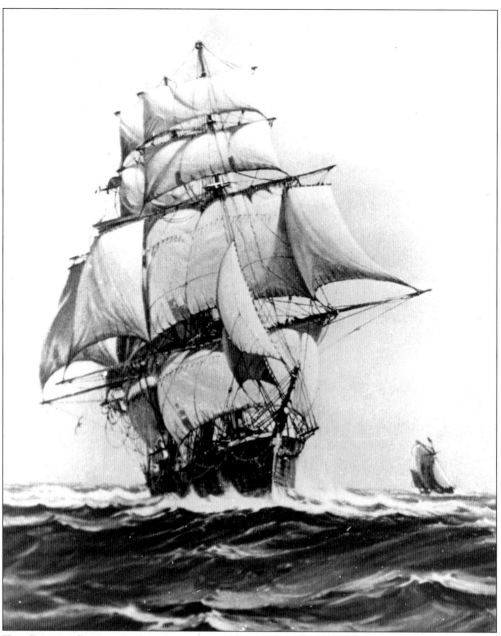

THE RECORD-BREAKING *RED JACKET*. Joshua N. Taylor wrote in his memoirs that later, while captain of the bark *George T. Kemp*, he "purchased (at Port Elizabeth) as a bit of speculation one ostrich, one tiger, and a large baboon, a regular man eater and a most vicious animal . . . a big Swede by the name of Swinson seemed to take delight in getting big Jocko angry . . . the baboon would scream, froth at the mouth and bend the bars of the cage . . . I had cautioned Swinson to keep away . . . he picked up the deck broom and poked it through the cage . . . there came a horrible scream from both man and beast. The baboon fastened both of his big tusks in the sailor's throat." Taylor himself stitched up the sailor's mangled throat. The man lived, and the baboon was sold to a circus. (Painting by R. Macgregor, Peabody Museum, Salem, Massachusetts.)

Three Women. From left to right are Eva Higgins, Carrie Harding, and Grace Doyle in a photograph taken by Henry K. Cummings. (Photograph courtesy of Mr. and Mrs. Stanley Snow.)

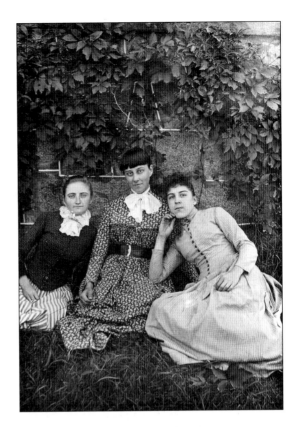

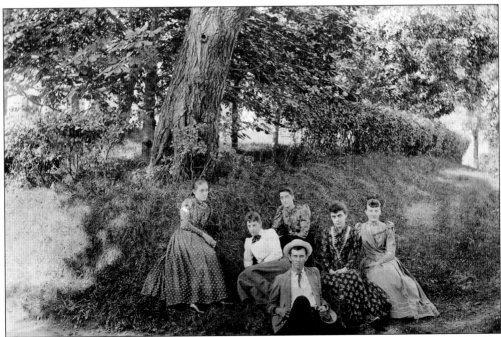

At Miss Martha's Corner. Shown in this Henry K. Cummings photograph are Theresa, Lena, Ida, Louis, and Clayton. (Photograph courtesy of Mr. and Mrs. Stanley Snow.)

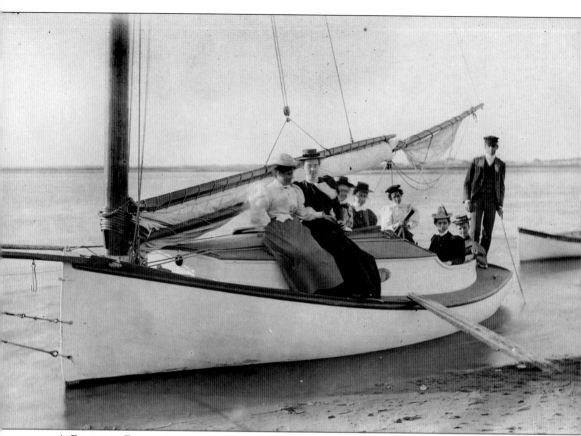

A BOATING PARTY ON THE *PURITAN*, 1898. Among the group are members of the Dennett, Parent, and Lang families. At the stern is Francis C. Cummings, brother of the photographer Henry K. Cummings. Cummings was one of the finest photographers ever to capture the people of Cape Cod on film. Many of his photographs grace this book. Born in 1865, he was the grandson of two sea captains, Joseph Cummings and Ebenezer H. Linnell. A talented businessman, he took over the family dry goods store at the corner of Main Street and the County Road. At 18, in 1883, he purchased his first camera and soon discovered his gift for natural portraits and for dramatic subjects such as shipwrecks and now-lost windmills and lighthouses. (Photograph courtesy of Mr. and Mrs. Stanley Snow.)

Five

WINDMILLS, SALTWORKS, AND CRANBERRY BOGS

*The most foreign and picturesque structures on the Cape, to an inlander . . . are the wind-
mills. . . . They looked loose and slightly locomotive, like huge wounded birds, trailing
a wing or a leg, and reminded one of pictures of the Netherlands.*
—Henry David Thoreau, *Cape Cod*, 1864.

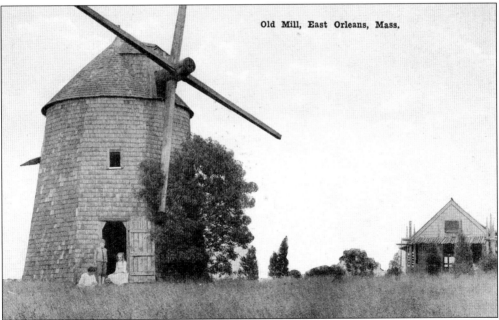

Old Mill, East Orleans, Mass.

THE EAST ORLEANS WINDMILL, BUILT C. 1800 FROM TIMBERS OF THE OLD
CONGREGATIONAL CHURCH. In 1819, Rev. Daniel Johnson moved this windmill from Snow's
Hill to Meetinghouse Pond by oxen. This smock-type mill is now at Heritage Plantation. The
sea held an abundance of cod and mackerel, but the land was sandy and poor. The people of
Orleans took every advantage of what nature provided, though, and built mills run by the tides
and the winds. They dried the lucrative salt from the sea and cultivated cranberries in the boggy
hollows. (Postcard courtesy of Mr. and Mrs. Stanley Snow.)

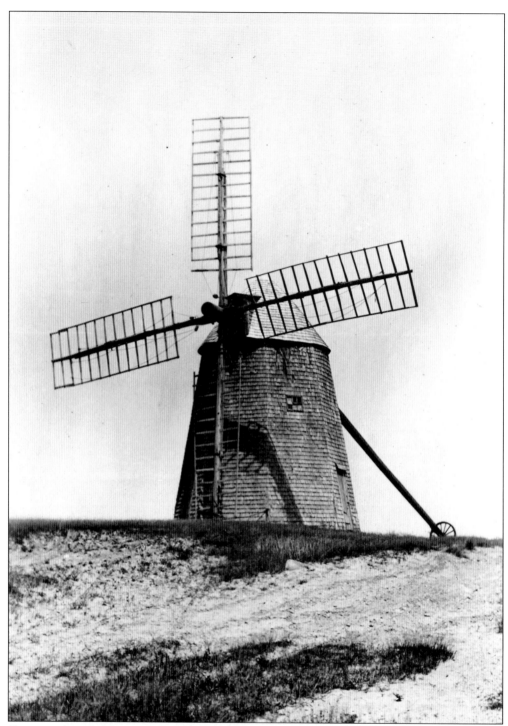

CAPTAIN AREY'S MILL, 1895. After 25 years as a sea captain in the fruit trade, James H. Arey bought and ran a gristmill. The old mill came from Chatham to a spot near Arey's Pond in 1830. In 1870, Arey moved it to Mill Hill, near the Tonset Road entrance to the cemetery. It was moved to Pocasset in 1905. (Photograph courtesy of Mr. and Mrs. Stanley Snow.)

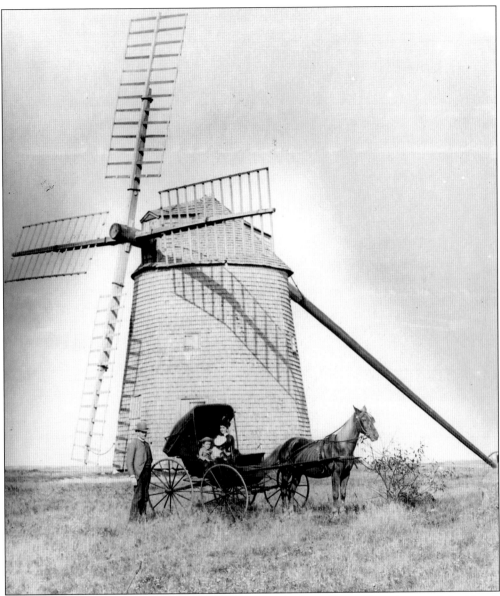

THE JONATHAN YOUNG WINDMILL. This icon overlooking Town Cove is one of the Cape's earliest and best-preserved windmills. Built in South Orleans *c.* 1750, it had for centuries ground corn, other grains, and rock salt from local saltworks. In 1839, it was moved to the hill near Jonathan Young's home, where the Governor Prence motel now stands. In 1897, Captain Hunt, a retired sea captain, moved the mill to his estate in Hyannisport. After Hunt's death, the mill was given to the Orleans Historical Society. The society transferred ownership of the historic windmill to the town and helped raise funds for its restoration. In 1983, the windmill was dismantled and moved to Orleans, where it is now the fully restored centerpiece of Town Cove Park. (Photograph courtesy of Mr. and Mrs. Stanley Snow.)

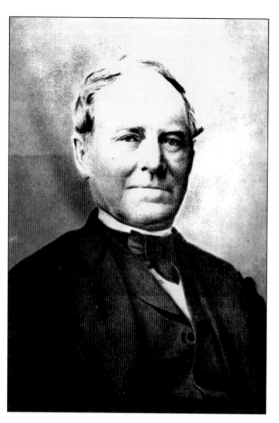

JONATHAN YOUNG. Oddly enough, Jonathan Young's profession was not that of miller. Apprenticed as a shoemaker in Provincetown at the age of 16, Jonathan Young soon returned to Orleans, where he had been born in 1808. He manufactured and sold boots and shoes, wed Mary Rogers, and enlarged his business. Young diversified from footwear to general goods, thrived, and invested in the windmill that today bears his name. (Photograph courtesy of the Orleans Historical Society.)

AN EXAMPLE OF SALTWORKS, SOUTH YARMOUTH. Little evidence remains today of the old saltworks that were so important for the preservation of fish. Before refrigeration, a fishing economy could not survive without salt. Small windmills drew saltwater into vats for sun drying. By 1837, Orleans had 50 prosperous saltworks. The discovery of salt mines in New York and the coming of refrigeration put an end to the industry and cleared the shores of its creaking mills. (Photograph courtesy of Mr. and Mrs. Stanley Snow.)

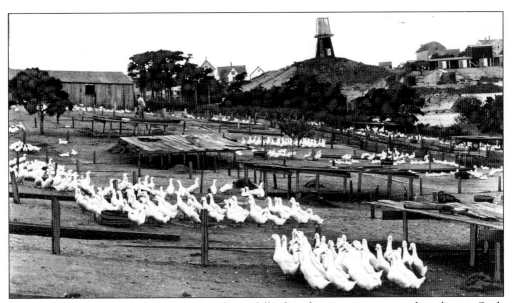

MAYO'S DUCK FARM. Some creative Orleans folks found unique ways to make a living. Such were the Mayos with their duck farm: "From the cemetery, you should continue on to Nauset Beach, and on the way you will pass a duck farm. The ducks are as white as the shadbush, and prettier than you would suppose. There must be thousands of them, and I suppose they would make a million sandwiches." (Eleanor Early, *And This Is Cape Cod!*, Houghton Mifflin, 1936. Photograph courtesy of Michael Parlante.)

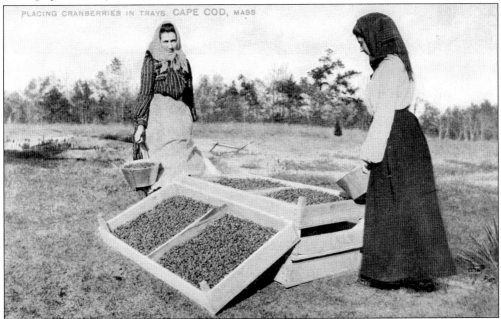

CAPE COD CRANBERRIES. Cranberries will forever be associated with the Pilgrims, Thanksgiving, and Cape Cod. They, along with blueberries and Concord grapes, are among the only fruits native to North America. The Native Americans called cranberries *sassamanesh* and mixed ripe berries with dried venison to make pemmican. As a medicine, they used them unripe and roasted to heal wounds. (Postcard courtesy of Mr. and Mrs. Stanley Snow.)

CULTIVATING AN ORLEANS CRANBERRY BOG. The cranberry was first cultivated by Henry Hall of Dennis. In 1816, he noticed that the wild cranberry vines in his bog yielded more fruit after sand had blown onto the plants. His experiments continued to increase the yield, which was profitably shipped in barrels made by his brother, Isaiah Hall. (Photograph courtesy of Mr. and Mrs. Stanley Snow.)

CRANBERRY BOG BUILDERS. These men are turning over the soil and planting vines for a cranberry bog at the north end of Orleans. The bog was later filled in to build the 20th-century shopping center by the Route 6 traffic rotary. (Photograph courtesy of Mr. and Mrs. Stanley Snow.)

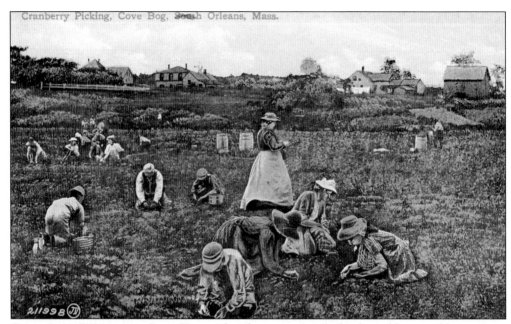

CRANBERRY PICKING AT COVE BOG. After three years, a newly planted bog would come into production. A single acre of cranberries could support an Orleans family in the 19th century. Several acres increased profits and the number of workers needed. Portuguese and Finnish immigrants arrived to help with the harvest, and some stayed to start their own vines. (Postcard courtesy of Mr. and Mrs. Stanley Snow.)

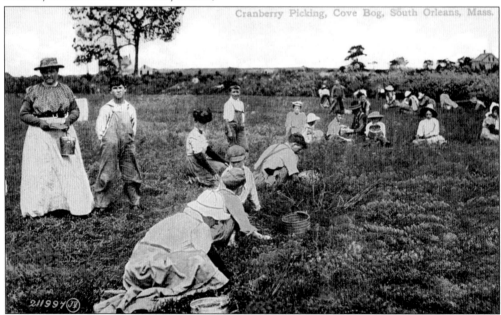

COVE BOG CRANBERRY PICKERS. The harvesting was done with bare hands until the late 1800s, when wooden scoops were introduced. A good picker could harvest 15 barrels a day. Wooden scoops were used until the 1950s. It was only in the 1960s that the wet method of harvesting was introduced—the flooding and floating of the berries. (Postcard courtesy of Mr. and Mrs. Stanley Snow.)

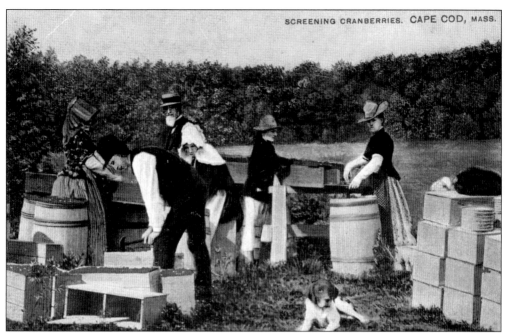

SCREENING THE BERRIES. Initial screening of the cranberries was done at the bog. It is said that John "Peg-Leg" Webb discovered that good cranberries bounced. Separators were developed to bounce berries over hurdles. (Postcard courtesy of Mr. and Mrs. Stanley Snow.)

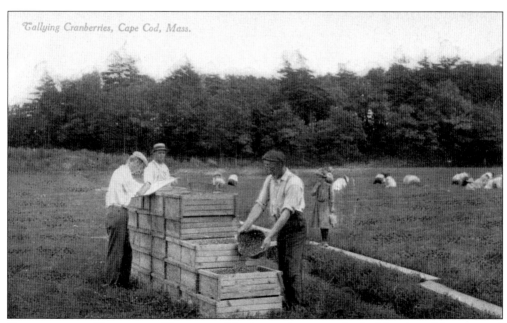

TALLYING THE CRANBERRY HARVEST. After screening away the bad berries, pickers poured them into barrels and crates to be shipped to buyers. Each picker's quarts were tallied at the end of the harvest, and the pay, before c. 1900, was $1^1/2$ cents per quart. (Postcard courtesy of Mr. and Mrs. Stanley Snow.)

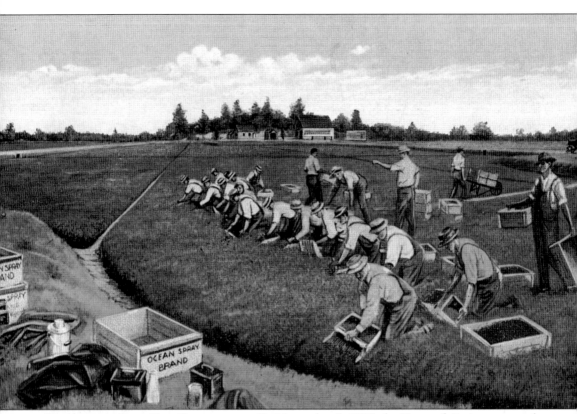

HARVESTING CAPE COD CRANBERRIES. On November 5, 1898, the *Yarmouth Register* reported: "Mrs. Dorcas Northrup of Rock Harbor . . . went to the cranberry swamp of Isaac Hopkins to pick berries for her use the coming winter. She was alone on the swamp and when night came her neighbor, Mrs. Benjamin Hopkins, saw her with a bag on her shoulder moving up the swamp. . . . On Saturday morning, Bennie Hopkins, a lad of about 13 years, on his way to his traps, saw an object on the swamp, and as he went to it found it to be Mrs. Northrup, and lying at her side a bag containing a few berries, and a measure beneath her. . . . He hastened for help and she was tenderly removed to the home of her sister, Mrs. Mercy Stevens. . . . Dr. S. T. Davis was of the opinion that she received a chill which caused a paralytic stroke . . . in a few hours she passed on to her spiritual home, to join her husband who departed this life in 1892." (Postcard courtesy of Mr. and Mrs. Stanley Snow.)

Six

THE FRENCH
CABLE STATION

Here come the Bosch. God help us.
—World War II message sent from France to Orleans.

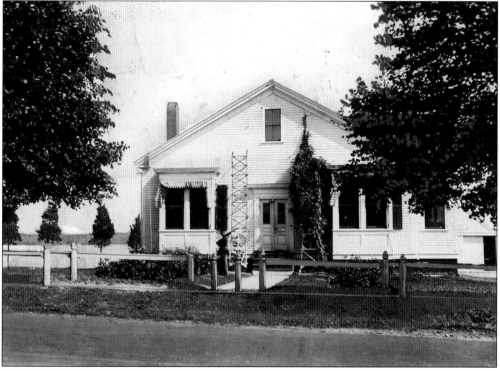

THE FRENCH CABLE STATION, EARLY 1900S, ROUTE 28. As fate would have it, Orleans, the Cape town with the French name, became literally connected to France by cable in the 1890s. The first transatlantic cable had connected Ireland and Newfoundland in 1858. Until then, it had taken weeks for a written message to travel aboard ship to Europe. With cable, a new technological era began—messages zipped across oceans in minutes. (Photograph courtesy of Michael Parlante.)

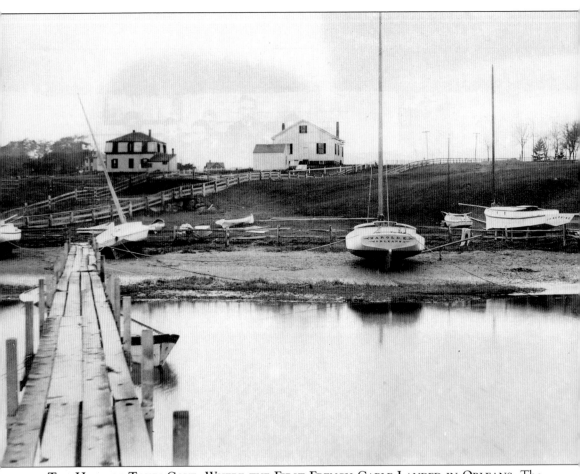

THE HEAD OF TOWN COVE, WHERE THE FIRST FRENCH CABLE LANDED IN ORLEANS. The French had initially laid a cable to North Eastham in 1879. Finding the spot too isolated for the station staff and too often inaccessible because of storms, the cable was extended to Orleans in 1891. The back of the cable station is pictured above the cove. (Photograph courtesy of Mr. and Mrs. Stanley Snow.)

THE FRENCH CABLE STATION UNDER CONSTRUCTION, C. 1890. This indirect connection, from France to Newfoundland to North Eastham to Orleans, lasted only briefly. North Eastham was soon discontinued and then, in 1898, the French laid cable directly from Deolen, near Brest, to Orleans. For many years this cable was the quickest communication link between Europe and the United States. (Photograph courtesy of Mr. and Mrs. Stanley Snow.)

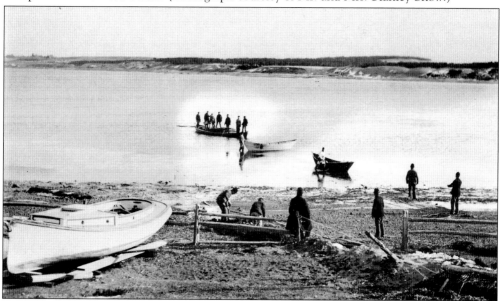

THE LAYING OF THE FRENCH CABLE IN TOWN COVE. This cable, 3,173 nautical miles long, was the longest at the time it was laid. It carried the news of the world for over 60 years. All communications to and from the American forces in World War I were sent over this line. U.S. Marines camped in the front yard to protect the station from sabotage. On July 21, 1918, a German submarine shelled this area in an attempt to destroy the cable. (Photograph courtesy of Mr. and Mrs. Stanley Snow.)

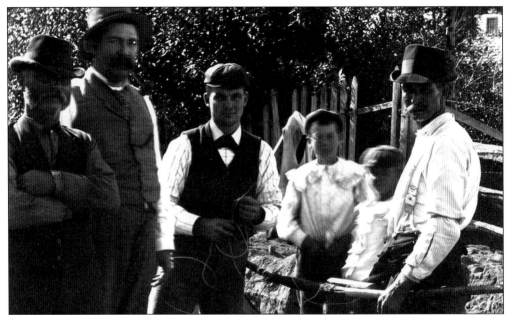

A Rare Photograph of a Crew Working on the French Transatlantic Cable. The Orleans cable station was connected overland to New York, just as the French station in Deolen was connected to Paris. It carried news of the sinking of the *Lusitania* in 1915 and, in 1927, boys playing baseball near the station were among the first to hear the news that Charles Lindberg completed the first solo flight across the Atlantic. Only 32 hours before, they had heard his plane flying overhead. (Photograph courtesy of John Bosko.)

A Postcard of the French Transatlantic Cable Station. In 1940, German submarines landed off Deolen and took the cable station there. The last message they sent to Orleans was "Here come the Bosch. God help us." The famous French transatlantic cable operated again, briefly, from 1952 to 1959, when it closed permanently on November 26. Today, it is open to the public as a museum dedicated to the great era of cable communication. (Postcard courtesy of Mr. and Mrs. Stanley Snow.)

Seven

SHIPWRECKS AND LIFESAVING

It is a stormy night and I am seated here in my room by the fire thinking of poor sailors on such a night as this. I never can rest well when the wind is howling as it does now. It seems to me that those who live on land can hardly imagine the sufferings of a life on the ocean. A great many poor fellow will find this a hard night.
—Letter of Mary Doane, Orleans, January 4, 1865. (The Orleans Historical Society.)

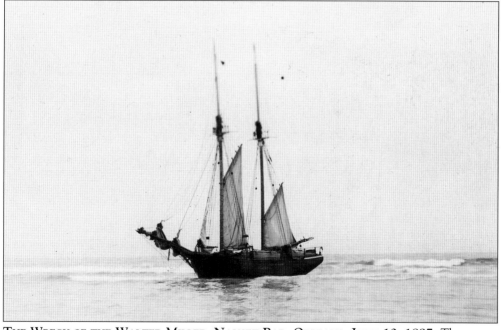

THE WRECK OF THE WALTER MILLER, NAUSET BAR, ORLEANS, JUNE 10, 1897. The waters off Cape Cod have long been considered among the most dangerous on the East Coast. Along the Cape's outer shore, the shoals near Orleans, once known as Tucker's Terror, are perhaps the Cape's most treacherous waters. At their sight, in November 1620, the captain of the *Mayflower* turned the ship around and brought the Pilgrims to safer waters at Provincetown. (Photograph courtesy of Mr. and Mrs. Stanley Snow.)

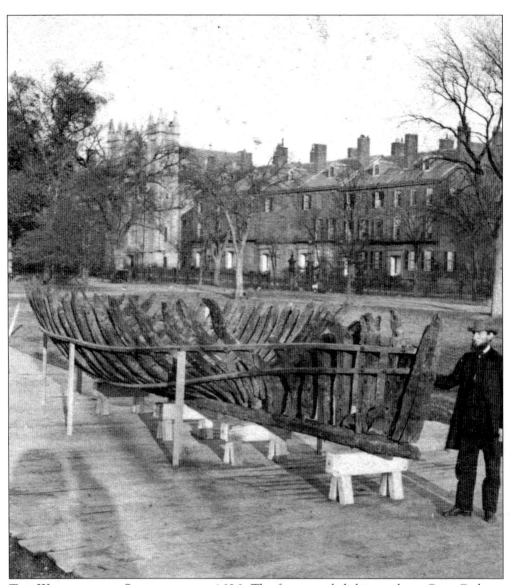

THE WRECK OF THE *SPARROWHAWK*, 1626. The first recorded shipwreck on Cape Cod was that of the *Sparrowhawk*. With 25 passengers aboard, Captain Johnston sailed her from Plymouth, England, for Jamestown, Virginia. A perilous six-week journey had left them with empty water casks and a captain with scurvy. Plimoth's Gov. William Bradford later described the ship striking the outer bar of Orleans in December 1626. The wind and sea "beat them over the barr into the harbor, wher they saved their lives and goods, though much were hurte with salt water." The *Sparrowhawk* rested in Old Ship Harbor (Pochet Harbor) until another storm beat it until it "was now wholy unfitte to goe to sea." The Nauset Indians offered to carry letters to Plimoth for help. The ship itself lay buried until briefly uncovered in 1782. Then, on May 6, 1863, Solomon Linnell and Alfred Rogers discovered the wreck in the mud. With it they found bones, shoes, and an opium pipe. Two years later, the skeletal remains of the *Sparrowhawk* were exhibited on Boston Common and then in Providence, as seen here. Today, the *Sparrowhawk* can be seen at the Pilgrim Hall Museum in Plymouth. (Photograph courtesy of Mr. and Mrs. Stanley Snow.)

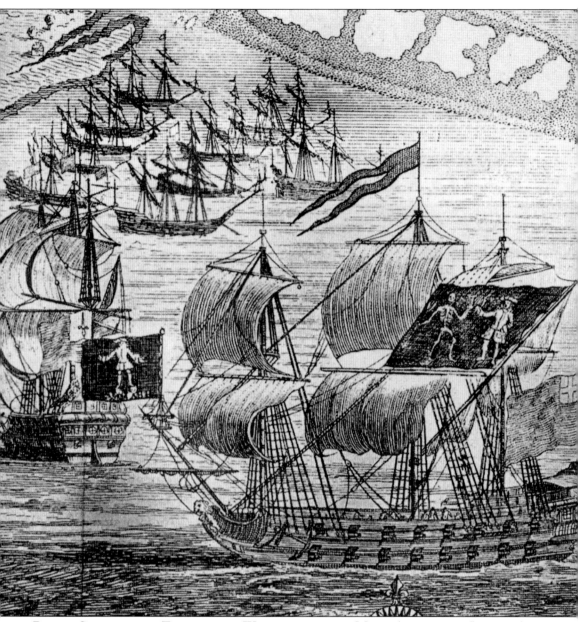

PIRATE SHIPS IN THE TIME OF THE *WHYDAH* AND THE *MARY ANNE*, FROM JOHNSON'S *GENERAL HISTORY OF THE PIRATES*, LONDON, 1725. On the night of April 26, 1717, the pirate ship *Mary Anne* wrecked on the outer bar of Orleans in a fierce storm. The ship had been captured by none other than the notorious pirate Sam Bellamy, whose own ship, the *Whydah*, went down off Wellfleet. More than 140 died that night. The *Mary Anne*, from Dublin, had been captured by Bellamy with a cargo of Madeira wine, and Bellamy's pirates were placed on board. Local men John Cole and William Smith were onshore when the *Mary Anne* wrecked and went out to save the men. Seven men were brought to safety and fed. When their rescuers realized they were outlaws, the men fled, only to be captured in Barnstable. Six of them were condemned to hang for piracy (one was deemed insane) on November 15, 1717, "at Charlestown Ferry within the flux and reflux of the Sea."

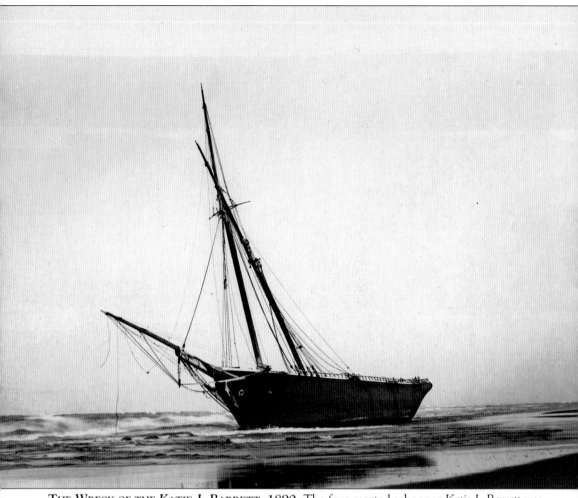

THE WRECK OF THE *KATIE J. BARRETT*, 1890. The four-masted schooner *Katie J. Barrett* was carrying a cargo of ice in February 1890 when it struck the bars a quarter mile east of the Nauset Inlet. Crews from the Orleans and Nauset Life Saving Stations saved the nine men aboard. The ship remained a ghostly image for seven months, until it could be refloated and towed to Boston for repairs. (Photograph courtesy of Mr. and Mrs. Stanley Snow.)

THE ORLEANS LIFE SAVING STATION, 1895. It was from this station on Nauset Beach that a fruitless attempt was launched to save the men of the *Calvin B. Orcutt*. The four-masted schooner sailed from Portland, Maine, and was caught in the terrible blizzard of December 23, 1896. The ship foundered four miles south of the Orleans station, but phone lines to the station were down. Henry K. Cummings fought through the blizzard to reach Supt. Benjamin Sparrow's house. Sparrow was unable to reach the station through the drifts until 1:00 a.m. The *Orcutt* and all hands were lost, however. For months, bodies washed up on the Outer Beach. (Photograph courtesy of Mr. and Mrs. Stanley Snow.)

BENJAMIN C. SPARROW, SUPERINTENDENT OF LIFESAVING STATIONS FOR THE STATE. Supt. Benjamin Sparrow and his men did all they could to save the men of the *Orcutt*. The headlines in the *Boston Herald* on December 24, 1896, read: "Schooner *Calvin B. Orcutt* Lost in the Raging Breakers. Big Four-Master Driven Upon the Bar in a Raging Gale and Blinding Snow—Icy Waves Dash Over Her, Masthead High— Eight Men, Lashed in Rigging, Frozen to Death—No Hand to Grasp Life Savers' Lines—Ill-Fated Craft Broken to Pieces." (Photograph Courtesy of Orleans Historical Society.)

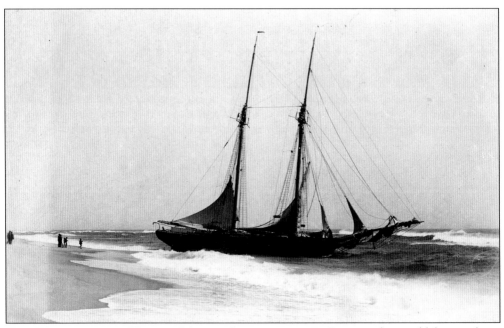

THE WRECK OF THE *WALTER MILLER*, JUNE 10, 1897. Summer fog could be nearly as treacherous as winter weather. The British schooner *Walter Miller* was heading from St. John, New Brunswick, to New York City with a cargo of lumber when it struck Nauset Bar in fog and a heavy sea. The crew of five and the captain's wife were rescued as waves broke over the stern of the ship. (Photograph courtesy of Mr. and Mrs. Stanley Snow.)

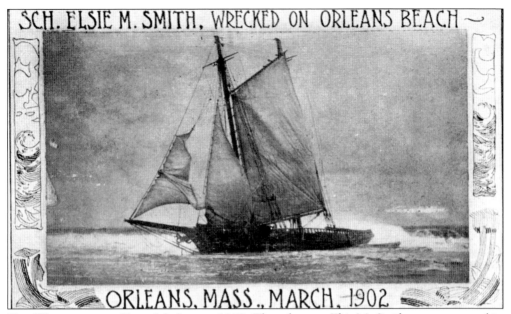

SCH. ELSIE M. SMITH, WRECKED ON ORLEANS BEACH ~

ORLEANS, MASS., MARCH, 1902

THE WRECK OF THE *ELSIE M. SMITH*, 1902. The schooner *Elsie M. Smith* came to an end in a storm in March 1902. Capt. James Charles and his crew at the Orleans Life Saving Station took ashore 16 men by shooting a line into the spars and using the breeches buoy. (Postcard courtesy of Mr. and Mrs. Stanley Snow.)

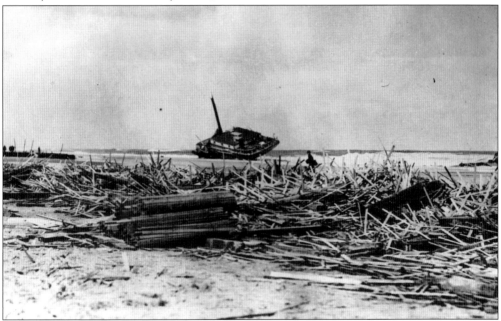

THE WRECK OF THE *MONTCLAIR*, MARCH 4, 1927. The *Montclair's* cargo of wooden lath lies scattered on the beach. Four days after leaving Halifax, Nova Scotia, the ship hit a northeast gale off Orleans. Writer Henry Beston was then living in his small house on Nauset Beach. The following is taken from his book *The Outermost House:* "There has just been a great wreck, the fifth this winter and the worst . . . the big three-masted schooner *Montclair* stranded at Orleans and went to pieces in an hour." (Photograph courtesy of Mr. and Mrs. Stanley Snow.)

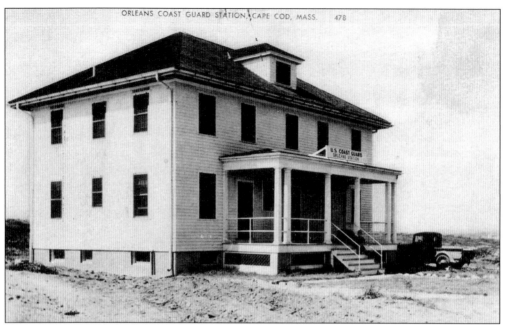

THE U.S. COAST GUARD STATION AT ORLEANS, LITTLE POCHET ISLAND. The crew from this station was able to save only one man from the *Montclair* in 1927. Henry Beston wrote: "Five clung to the skylight of the after deckhouse. . . . One great sea drowned all the five. . . . A week after the wreck a man walking the Orleans shore came to a lonely place, and there he saw ahead of him a hand thrust up out of the great sands. Beneath he found the buried body of one of the *Montclair*'s crew." (Photograph courtesy of Mr. and Mrs. Stanley Snow.)

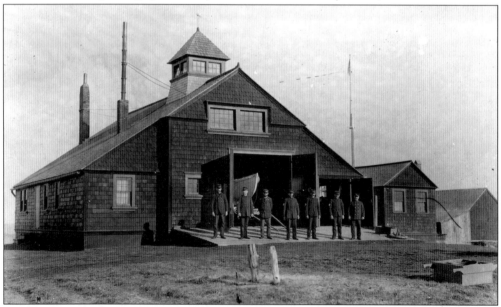

THE ORIGINAL ORLEANS LIFE SAVING STATION. This was one of the nine stations built on the Cape when the U.S. Life Saving Service was formed in 1872. Until then, sailors relied on volunteers of the Massachusetts Humane Society who set up shelters with supplies along the beaches. (Photograph courtesy of Mr. and Mrs. Stanley Snow.)

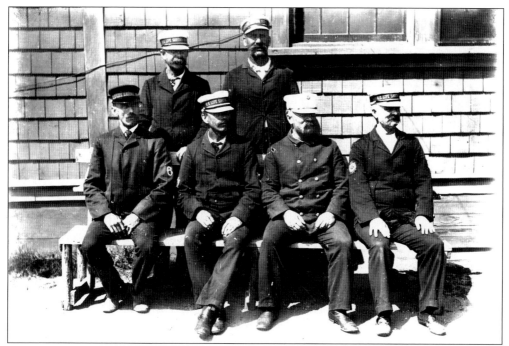

THE ORLEANS LIFESAVING CREW, AUGUST 31, 1903. Crews normally had a keeper and six surfmen. The beaches were patrolled each night, one man heading north and another heading south from the station. Each would reach a halfway house and exchange checks with a surfman from the adjacent lifesaving station, who met him there after patrolling from the opposite direction. (Photograph courtesy of the Orleans Historical Society.)

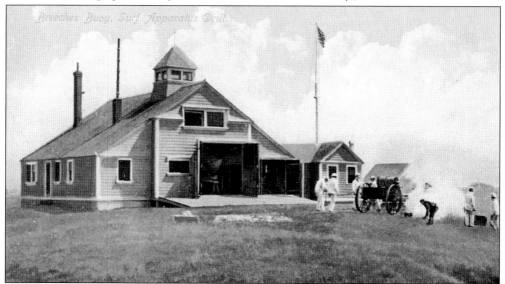

A BREECHES BUOY DRILL, ORLEANS LIFE SAVING STATION. When the surf was too violent to launch the boats, the breeches buoy was used. A small cannon shot a line out to the shipwreck. A pair of canvas breeches was suspended from the line with a pulley system, and one victim at a time was rescued. Weekly drills kept crews in top shape for this extremely hazardous duty. (Photograph courtesy of Mr. and Mrs. Stanley Snow.)

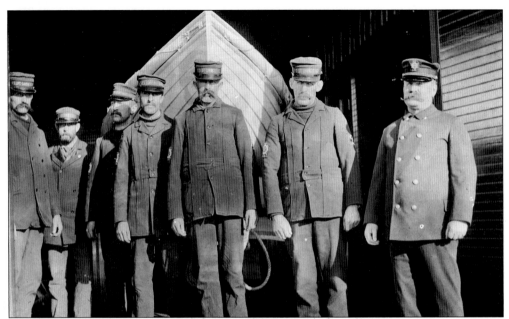

Capt. James H. Charles (Right) and His Orleans Lifesaving Crew, 1900. The son of a sea captain, James Charles devoted his career to saving lives as keeper of the Orleans Life Saving Station. In *The Life Savers of Cape Cod*, J.W. Dalton wrote: "Captain Charles and his crew have made many daring rescues both by surf-boat and breeches-buoy . . . and have often suffered untold hardship . . . they are ever ready to battle with the wind or wave." (Photograph courtesy of Mr. and Mrs. Stanley Snow.)

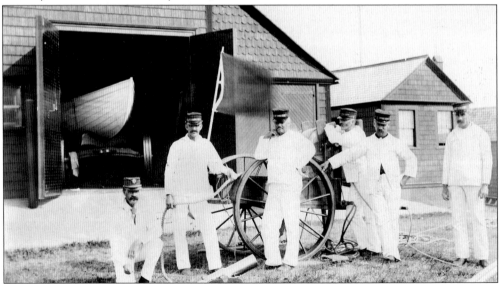

The End of the Orleans Life Saving Station. One of the last crews of the station poses with the Lyle gun used for breeches buoy rescues. With the opening of the Cape Cod Canal in 1914, shipping avoided the treacherous voyage around the Outer Cape. Radio, wireless telegraphy, and diesel engines helped reduce the numbers of catastrophes at sea. In 1915, the era of the lifesavers of Cape Cod came to an end when the U.S. Life Saving Service was incorporated into the U.S. Coast Guard. (Photograph courtesy of Mr. and Mrs. Stanley Snow.)

Eight

ORLEANS TWICE ATTACKED

Allies Have Huns on the Run. Attack By U-Boat off Cape.
—Headline of *Boston Daily Globe Extra,* July 22, 1918.

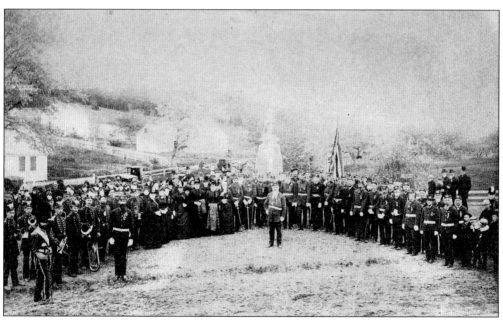

THE DEDICATION OF THE ORLEANS CIVIL WAR SOLDIERS MONUMENT, MAIN STREET AND MONUMENT ROAD. Like Orleans, most towns have stories of soldiers who went off to war. Orleans is unique in America, however, for being a town twice attacked by foreign countries. The British invaded Rock Harbor in the War of 1812, and during World War I, a German U-Boat sank barges off Nauset Beach and shelled the Orleans shore. (Photograph courtesy of the Orleans Historical Society.)

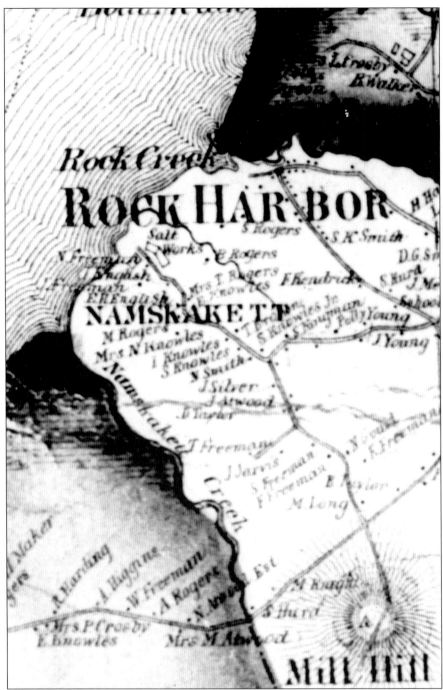

ROCK HARBOR, HENRY F. WALLING MAP, 1858. The Battle of Rock Harbor occurred on December 19, 1814. The British had sent a squadron of warships to patrol the bay and blockade Boston Harbor. The *Newcastle* kept close watch on Orleans, which had refused to pay ransom for protection and was known as a haven for ships attempting to run the blockade. Moreover, Orleans was hiding tackle blown from the deck of the *Newcastle*. The ship sent in four barges to attack Rock Harbor.

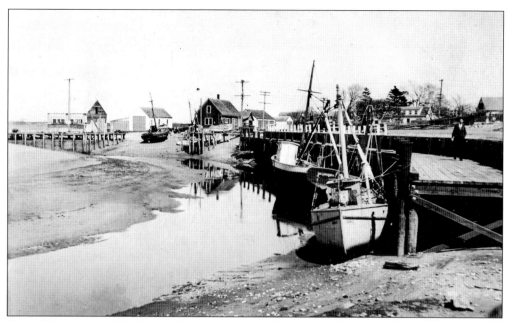

ROCK HARBOR, 1935. During the raid on Rock Harbor, the British set fire to the pier and a nearby saltworks. They captured the schooner *Betsy*, attacked the sloops *Camel*, *Washington*, and *Nancy*, and set two of them afire. The Orleans Militia fired from among the trees, killing one British marine, while enemy shells rained over the town. The British returned to the *Newcastle* and left Orleans to put out the fires. (Photograph courtesy of the Orleans Historical Society.)

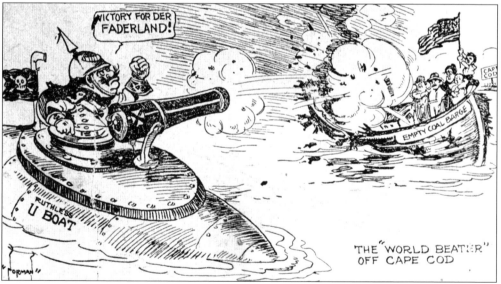

A BOSTON GLOBE CARTOON, APPEARING AFTER THE SHELLING OF ORLEANS, JULY 21, 1918. As the Allies pushed back the Germans in Europe during the summer of 1918, Grand Adm. Alfred Von Tirpitz sent seven of his largest submarine U-boats to harass shipping along the American coast. German submarine U-156 approached Cape Cod and spotted a tug and four barges off Orleans. On Sunday morning, July 21, 1918, Orleans became the only U.S. town to be shelled during World War I. (Photograph courtesy of the Orleans Historical Society.)

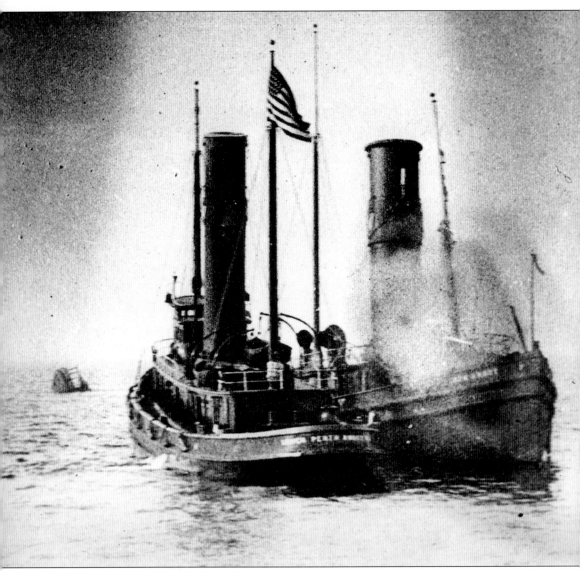

THE TUG *LEHIGH* ATTEMPTING TO EXTINGUISH FLAMES ON THE *PERTH AMBOY*. At about 10:30 a.m., people along Nauset Beach heard a series of sharp booms and looked out to sea. Two miles beyond the Nauset Harbor inlet was a tugboat towing four barges. Farther out, a German submarine had emerged. More than 200 feet long, with two deck guns, a machine gun, and 18 torpedoes, the submarine was determined to sink the little flotilla. (Photograph courtesy of the Orleans Historical Society.)

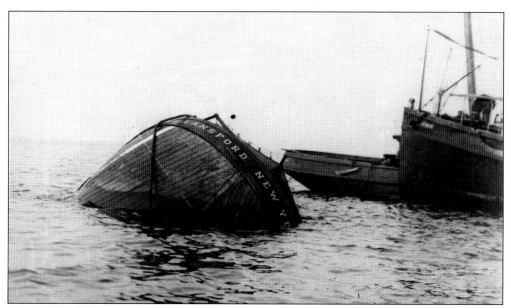

THE SINKING OF THE BARGE LANSFORD. The powerful tug *Perth Amboy* had left Portland, Maine, with three empty coal barges. Capt. James Tapley, his wife, and a crew of 17 stopped at Gloucester to pick up a fourth barge, the *Lansford*. On board were Capt. Charles Ainsleigh, Mrs. Ainsleigh, and two sons, Charles Dwight, and 11-year-old Jack Ainsleigh. It was probably the French transatlantic cable station rather than barges that drew the submarine to Orleans. (Photograph courtesy of the Orleans Historical Society.)

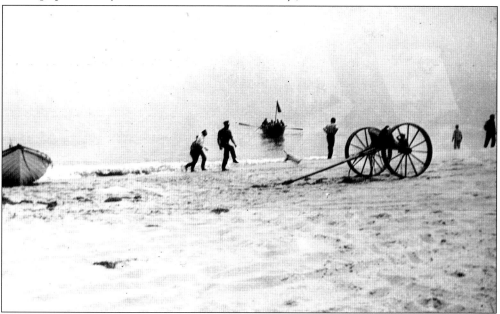

THE LIFEBOAT OF THE *PERTH AMBOY* APPROACHING SHORE. When the first shots were fired from the U-boat, Capt. James Tapley ordered the crew of the *Perth Amboy* to prepare the lifeboat. The first two shots had missed, but the third struck the tug, injuring John Botovich and John Vitz. Vitz recalled, "I was sleeping in my bunk when—Bang! I woke up and half the pilot house was gone." (Photograph courtesy of the Orleans Historical Society.)

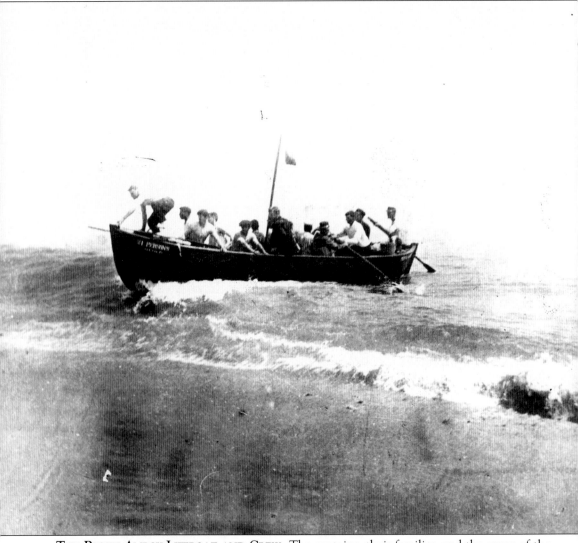

THE *PERTH AMBOY* LIFEBOAT AND CREW. The captains, their families, and the crews of the four barges tried to leave their vessels as the *Perth Amboy* began to burn. Two shots splintered the barge *Lansford*, injuring Capt. Charles Ainsleigh. According to Albert E. Snow, the only retaliatory fire from the attacked vessels was from the captain's son Jack Ainsleigh, "who fired his 22. cal rifle at U-156." It may have been older brother Charles Dwight Ainsleigh who held the rifle, while he excitedly waved the flag at the Germans. His father said, "Jack appeared to enjoy the whole affair." (Photograph courtesy of the Orleans Historical Society.)

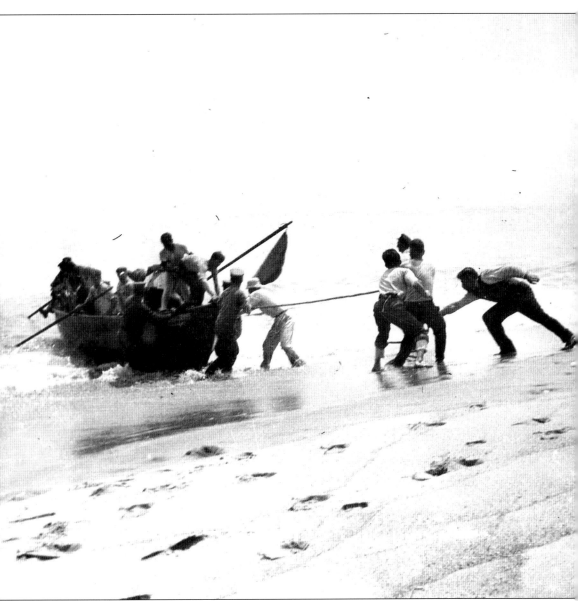

THE LANDING OF THE SURVIVORS OF THE *PERTH AMBOY*. Three of the barges were immediately sunk, and the submarine kept firing until the fourth went down. Meanwhile, the fishing boat *Rosie* wandered within range. The German deck guns shelled the boat and sprayed the deck with machine-gun fire. All hands abandoned the *Rosie* but returned after the action died down and sailed the boat to Provincetown. (Photograph courtesy of the Orleans Historical Society.)

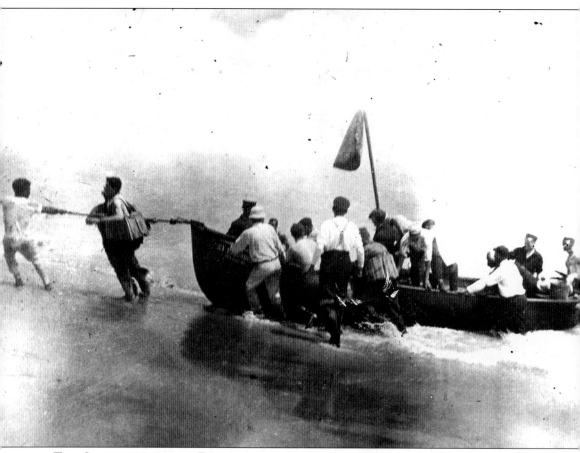

THE SURVIVORS OF THE *PERTH AMBOY* LEAVING THE LIFEBOAT. The German U-boat continued shelling the vessels and the beach for about an hour. Giuseppi Massetti was on the north shore of the Nauset Inlet when a shell burst before him: "There was a spurt of flame, a puff of smoke, then a sort of shrieking, whining noise and next I saw sand flying in all directions." Another shell hit a mile inland, in Meetinghouse Pond. Mrs. Weston Taylor was in her kitchen at the time: "It was as if a gigantic rocket came over the house. There was a great hissing and sizzling sound. It did not seem to be more than a few feet above the roof of the house." (Photograph courtesy of the Orleans Historical Society.)

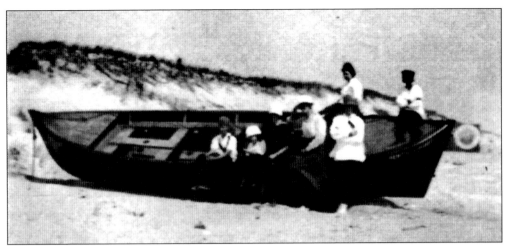

CHILDREN PLAYING IN THE *PERTH AMBOY* LIFEBOAT AFTER THE ATTACK. U.S. Navy planes arrived from Chatham and attempted to sink the submarine. The planes swept over, dropping bombs, yet all proved to be duds. One story passed down claims that "the disgusted pilot of one of the planes tossed down a monkey wrench and scored the only direct hit." Scott Corbett reported, "The U-boat [submerged] but only because the captain decided it was time to go anyway." (Photograph courtesy of the Orleans Historical Society.)

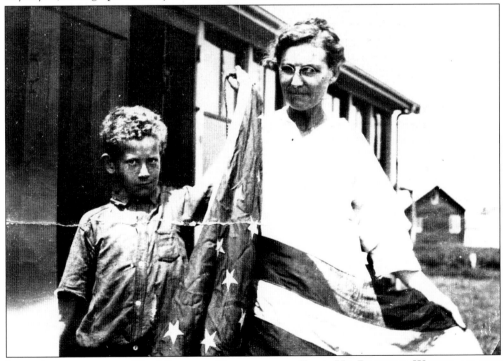

JACK AINSLEIGH AND HIS MOTHER, HOLDING THE FLAG HE BRAVELY WAVED AT THE ATTACKING GERMANS. One near casualty of the sinking of the barge *Lansford* was Jack Ainsleigh's dog Rex. Blown off the barge, he was later saved by Walter Eldredge. One of the hens kept on the barge floated ashore herself, still on her nest. Neighborhood children exhibited her for a fee as a "sea-going hen that the Huns didn't get." Proceeds went to the Red Cross. (Photograph courtesy of the Orleans Historical Society.)

Mrs. Ainsleigh, Jack Ainsleigh, Capt. Charles Ainsleigh, and Charles Dwight Ainsleigh. The Ainsleighs pose with the .22-caliber rifle and U.S. flag that the children used to threaten the attacking German submarine as the family barge was hit. German submarine U-156 left the Cape unharmed. Of the seven U-boats sent to America, only the U-156 failed to return to Germany. In September 1918, the only submarine to bomb U.S. soil in World War I struck a mine between Scotland and Norway and sank with its crew. (Photograph courtesy of the Orleans Historical Society.)

Nine

INNS, TRAVELERS, AND SUMMER PEOPLE

Full summer means . . . city children who learn what free running can mean as they race up and down Skaket beach . . . parents who spread the picnic on the warm sand and feel the tenseness of urban living drain away. . . . countless people dream of this all year, and save for it, and feel they have a handhold on Heaven even if only for one week or two.
—Gladys Tabor, My Own Cape Cod, Harper & Row, 1971.

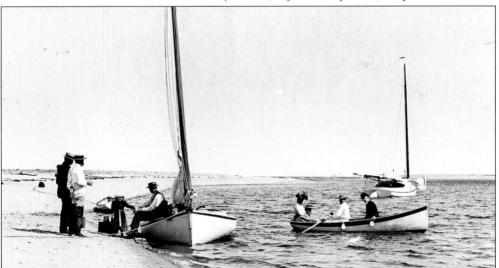

SOME BOATERS ON NAUSET. Orleans began hosting visitors long before the Cape became known as a resort. In 1797, Widow Keziah Harding had a tavern, opposite the present Snow Library, where the first meetings of the town were held. Maj. Henry Knowles kept a tavern on the Main Road in 1800, and there was one on Rock Harbor Road by 1812. Taverns normally kept rooms for travelers, and the best known of the early travelers was writer Henry David Thoreau. In 1849, he went as far as Sandwich by train and arrived in Orleans by stagecoach. His writings on the Cape, published in 1865, helped the world focus attention on its extraordinary natural beauty. In that same year, the extension of the railroad made travel to the town easier, and Orleans felt the first stirring of summer visitors. (Photograph courtesy of Mr. and Mrs. Stanley Snow.)

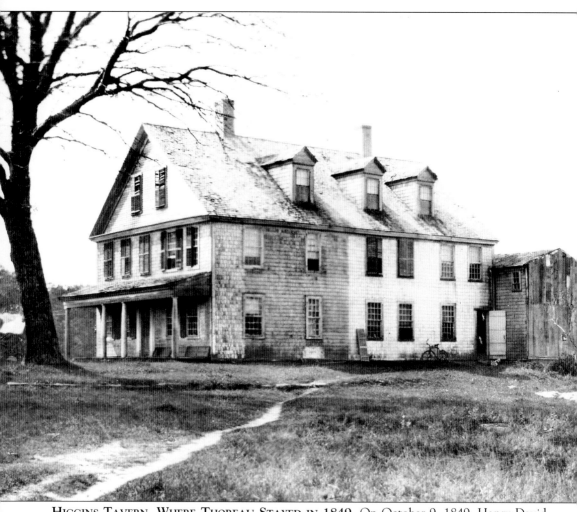

HIGGINS TAVERN, WHERE THOREAU STAYED IN 1849. On October 9, 1849, Henry David Thoreau and his friend Channing set out from Concord on an excursion that would form the most famous Cape Cod narrative in literature. Reaching Sandwich on October 10, it is likely that Orleans taverner and stage driver Simeon Higgins picked them up in his stagecoach. He brought them to the tavern he had owned since at least 1829. Today, a marker is found at the site on Route 6A, near the town center. Thoreau wrote in his journal, "The next morning . . . it rained as hard as ever; but we were determined to proceed on foot, nevertheless. We first made some inquiries with regard to the practicability of walking up the shore on the Atlantic side to Provincetown . . . Higgins said . . . that we could go very well, though it was sometimes . . . dangerous walking under the bank, when there was a great tide, with an easterly wind, which caused the sand to cave." (Photograph by Clifton Johnson, courtesy of the Jones Library, Amherst.)

AN ORIGINAL MANUSCRIPT FROM THOREAU'S JOURNAL. "At length we stopped for the night at Higgins' tavern in Orleans, feeling very much as if we were on a sand bar in the ocean and not knowing whether we should see land or water ahead when the mist blew away. We here overtook two Italian boys, with their hand organs, who had walked thus far down the Cape through the sand, and were going on to Provincetown. The thought that they had chosen wisely to come here where other music than that of the surf must be rare, provided they had strong backs. They told us that sometimes they got ten cents in a day, sometimes more, and sometimes nothing at all. When they got nothing or had to pay more than ninepence for their lodging, they did not buy anything to eat. They looked exactly like Indians." When Thoreau and Channing left Higgins Tavern on October 11, 1849, they hiked around Nauset Harbor and north across Jeremiah's Gutter, the old canal that once bisected the Cape. (Manuscript courtesy of Michael Parlante.)

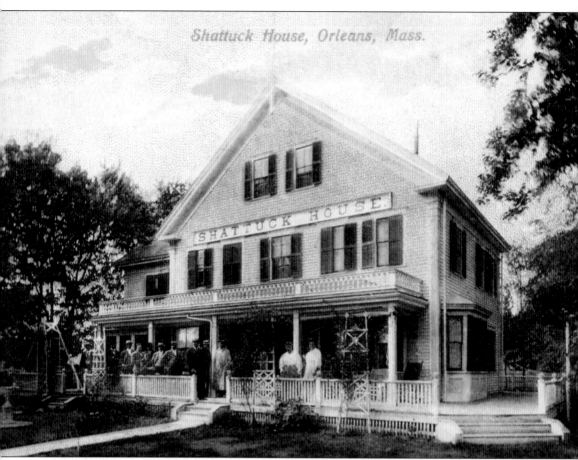

THE SHATTUCK HOUSE, CORNER OF THE COUNTY ROAD (ROUTE 6A) AND MAIN STREET.
The Shattuck House was the most central and best known of the inns of Orleans. Carmi H. Shattuck built the hotel in 1874 and ran it until his death in 1886. Visitors who arrived by rail counted on the Shattuck House for a good room and on the Shattuck stable for excursions. (Postcard courtesy of Mr. and Mrs. Stanley Snow.)

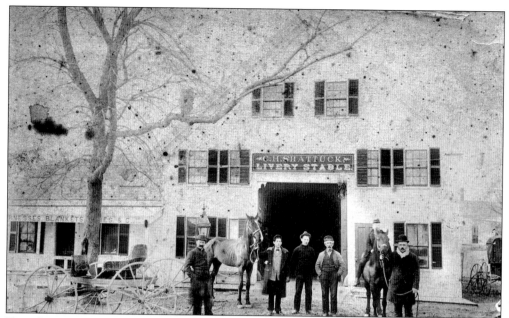

THE SHATTUCK HOUSE LIVERY STABLE. Carmi Shattuck, born in 1852, was the son of blacksmith and taverner Abel Shattuck. He had kept a livery stable for years before the blossoming of his hotel. (Photograph courtesy of Mr. and Mrs. Stanley Snow.)

A HORSE AND CARRIAGE AT THE SHATTUCK HOUSE LIVERY STABLE. After the original inn burned down, Carmi Shattuck had another house moved to the site. The hotel and livery stable stood until the 1930s. As sometimes happened to livery stables, this one was replaced by a gas station, and a gas station remains there today. (Photograph courtesy of Mr. and Mrs. Stanley Snow.)

THE WILLOWS BOARDINGHOUSE, CORNER OF CHAMPLAIN AND MILL POND ROADS. In 1890, Simeon Deyo wrote that Orleans "has attractions for the lover of rural beauty, and the summer visitor here finds the ocean and its grandeur in the midst of a most hospitable people." The Willows was originally owned by Johnny Snow and, in the early 1900s, Will Potter began hosting summer people there. (Photograph courtesy of Mr. and Mrs. Stanley Snow.)

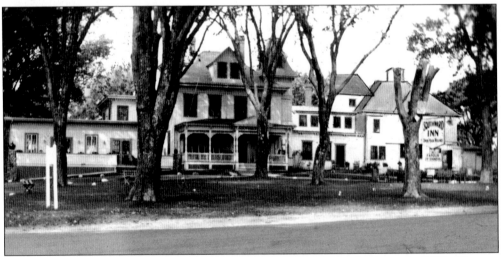

THE SOUTHWARD INN, CORNER OF ROUTE 28 AND COVE ROAD. In the early 1900s, Thomas Newcomb opened his large, mansard-roofed home as an inn. The sign in this photograph reads, "Southward Inn, Open Year Round, Famous for Dancing." The ballroom in the carriage house, with its special dance floor laid over springs, was indeed famous, summer or winter. The inn hosted many weddings and honeymoons until it was torn down in the 1970s. (Photograph courtesy of Michael Parlante.)

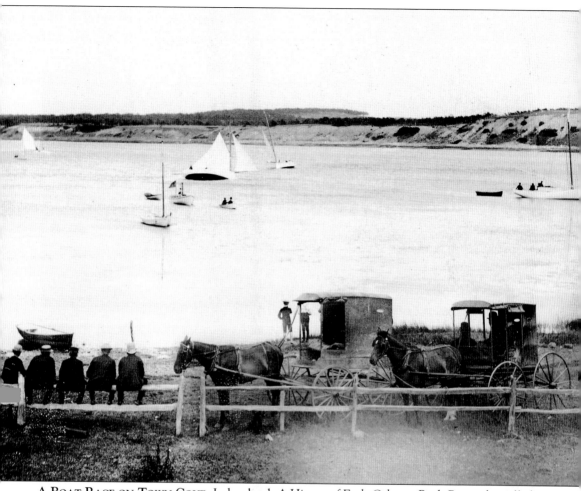

A BOAT RACE ON TOWN COVE. In her book *A History of Early Orleans*, Ruth Barnard recalled weeks of boating and dancing, after her family stepped off the train for the summer: "Joe Taylor first drove the 'summerfolks,' [and] later Walter or Cy Young piloted the depot wagon. We picked up the news of the winter from them. We arrived when the wild roses bloomed and soon the hay stood high." After renting rooms, in 1903, her family bought a big double-cape from Austin Snow. She recalled seafaring folk, such as Sarah Snow, who had seen many exotic ports and who "had a pet monkey and often as she talked with us her little pet would climb up and sit atop her head looking wisely at us." (Photograph courtesy of Mr. and Mrs. Stanley Snow.)

CAMP NAUSET AT TONSET. By 1897, recreational hunters and campers were drawn to the beauty and abundance of Pleasant Bay. The first camp specifically for children appeared in 1900 and was followed by a dozen others. Several generations of campers sailed, swam, hiked, danced, and played archery and tennis, until the last camp, Namequoit, closed in 1988. (Photograph courtesy of Mr. and Mrs. Stanley Snow.)

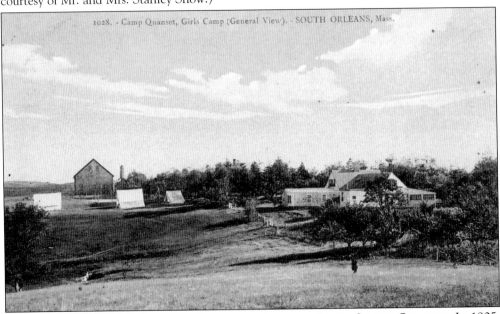

THE QUANSET SAILING CAMP FOR GIRLS, OFF QUANSET ROAD, SOUTH ORLEANS. In 1905, Mary L. Hammatt started a camp for girls in tents behind the family farm. At first, the girls swam, played volleyball, worked on Native American crafts, and made fudge. By 1912, bunks were built and the emphasis was firmly on sailing. Girls from all over the United States and from Canada, Mexico, Japan, and Belgium came for glorious summers of day sails, races, and moonlight cruises. (Postcard courtesy of Mr. and Mrs. Stanley Snow.)

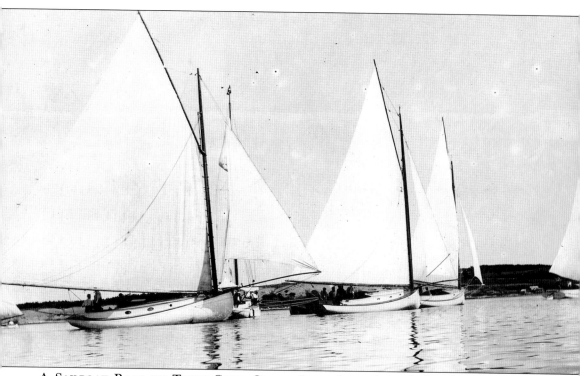

A SAILBOAT RACE ON TOWN COVE. Simeon Deyo observed the fresh influx of off-Cape visitors and wrote in 1890, "The sloping banks of Pleasant bay, in which, and in its tributaries and coves, the best of fishing abounds, the wooded knolls and healthful breezes render the territory a conspicuous site for pleasure seekers." (*History of Barnstable County*. Photograph courtesy of Mr. and Mrs. Stanley Snow.)

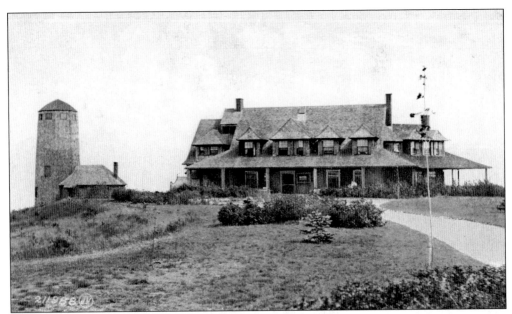

THE S.W. WINSLOW HOUSE, SOUTH ORLEANS, 1921. Sidney Winslow made his fortune as a shoe manufacturer and built his summer home on a bluff overlooking Pleasant Bay. (Photograph courtesy of Michael Parlante.)

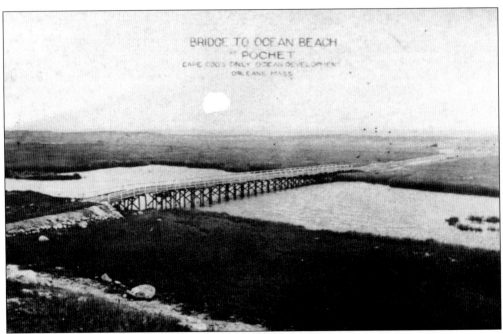

THE OLD BRIDGE FROM POCHET NECK TO NAUSET BEACH. In 1925, a syndicate called Orleans Associates Inc. bought Asa Mayo's 125-acre farm on Pochet Neck. Plans for the development of 119 lots, a yacht club, and tennis courts never materialized. After two years, only 16 lots were sold, and this bridge from the end of Pochet Road to the beach had been built. In 1928, the Cape Cod Five foreclosed. (Postcard courtesy of Mr. and Mrs. Stanley Snow.)

SEA CALL FARM, TONSET ROAD. The story of the Fiskes and Sea Call Farm is from that golden transitional time when land on the Cape seemed plentiful and those with a love for the sea could cheaply move part-time to paradise. The Fiskes did not seek a summer mansion but some land by the water, where they could farm and become part of the community. Like others, they ended up staying, and now their farm represents a triumph of land preservation for Orleans. (Photograph courtesy of Mr. and Mrs. Stanley Snow.)

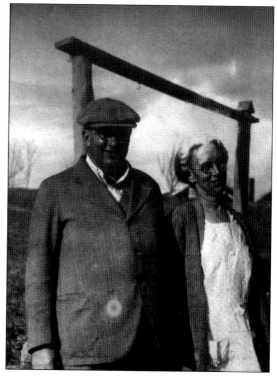

WILLIAM A. AND BERTHA FISKE. William and Bertha Fiske bought over six acres on Tonset Road in 1922. They built an eight-room farmhouse and greenhouses, overlooking Town Cove. They had 450 feet of frontage, beyond which were some of the richest shellfish beds in Orleans. Fiske worked for the American Railway Express Company in Connecticut. The couple and daughter Gertrude Fiske eagerly spent every spare moment at Sea Call, turning it into a productive local landmark. (Photograph courtesy of Mr. and Mrs. Stanley Snow.)

GERTRUDE FISKE AND FRIENDS AT SEA CALL FARM. Writer Gladys Tabor wrote of the farm in springtime: "Across from the old cemetery, I look at Sea Call Farm . . . Miss Fiske raises flowers to sell and has a big garden which slopes from the house to the road and is burnished with color all summer long. She cuts bouquets and sets them in the cool dark of a shed, in green and white and blue mixing bowls." (My Own Cape Cod, Harper & Row, 1971. Photograph courtesy of Mr. and Mrs. Stanley Snow.)

SEA CALL FARMHOUSE. Bill Fiske left extensive diaries, found later by James Snow and preserved at the Orleans Historical Society. "Sept. 27th, 1929. The glad flowers were still in bloom and lovely as ever. Nearly every bulb in the little lot bloomed. We have some of the nicest potatoes you ever saw. . . . After breakfast we went to Rock Harbor to get some fish. . . . We knew the oysters grew at South Chatham so over we go and get two quarts of them. . . . Nov. 10th, 1930. As we close the season the next season looms up big with promise and we all look forward to it with great expectations." (Photograph courtesy of Mr. and Mrs. Stanley Snow.)

SEA CALL FARM, FROM THE SHORE. Today, Sea Call is town-owned and the grounds—with community gardens, water views, and paths—are open to the public. James Snow and the Sea Call Supporters have triumphantly preserved part of a time nearly lost. After Orleans bought the place in 1987, some wanted to tear down the house. The Sea Call Supporters succeeded in restoring and preserving what historian Bonnie Snow has termed "the last farm of its kind in Orleans." (Photograph courtesy of Mr. and Mrs. Stanley Snow.)

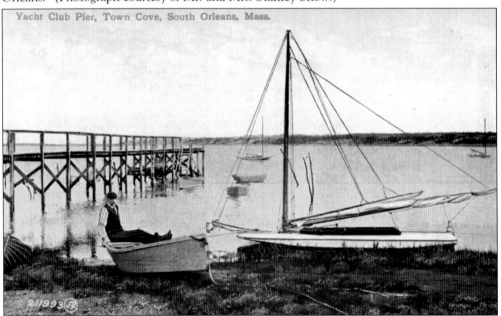

Yacht Club Pier, Town Cove, South Orleans, Mass.

THE YACHT CLUB PIER, END OF COVE ROAD, TOWN COVE, FOUNDED IN 1947. By the beginning of the 20th century, America's middle class had grown, making possible leisurely vacations on Cape Cod. Industrial wealth helped spawn large summer homes and yacht clubs, such as this one, and the Quanset Yacht Club, founded in 1936. (Postcard courtesy of Mr. and Mrs. Stanley Snow.)

ORLEANS INN · ON QUAINT CAPE COD · ORLEANS, MASS.

THE ORLEANS INN, LATE 1940s. Since 1875, Aaron Snow's house has been an unofficial symbol of the town of Orleans. Today, its handsome mansard roof and position at the head of Town Cove, next to the Jonathan Young Windmill, fill out an irresistible skyline. Born in 1827, a descendant of Nicholas Snow, Aaron Snow ran a grain and coal business here. His trading schooner, sailing from his own wharf, supplied the town with many of life's necessities, and thus laid the foundation for the noted Snow family store. He moved his business into the center of town and built the prominent Snow Block in 1885. Meanwhile, over the years his house was added to, sold, and run as a hostelry. Called at one time the Inn of the Yankee Fisherman, it is known today as simply the Orleans Inn. (Postcard courtesy of Mr. and Mrs. Stanley Snow.)

THE EAGLE WING HOUSE, SITE OF THE CENTER POST OFFICE, C. 1930. Lawyer, horticulturist, and education advocate Squire John Doane lived here until his death in 1881. Later, as the Eagle Wing House, it became a good example of the golden age of Orleans summer guesthouses. For a short while, the house became the Gull Hill School and, later, part of the house was moved to Monument Road. (Postcard courtesy of Mr. and Mrs. Stanley Snow.)

ORLEANS OLD HOME WEEK, AUGUST 1921. Orleans became fully aware of its rich history with its Centennial Celebration of 1897, during which "the bright and stirring town" welcomed Gov. Roger Wolcott to mark the occasion. The Old Home Week of 1921, pictured here, saw the return of many who had lived in or loved Orleans. The parade crossed the railroad tracks on Main Street by the Orleans Market, today the site of H.H. Snow and Sons Store. (Photograph courtesy of Mr. and Mrs. Stanley Snow.)

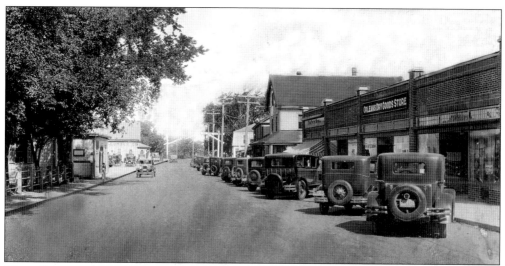

MAIN STREET, 1929. This view—looking down Main Street toward the railroad tracks and Rock Harbor—shows the growth of the town center. Shops, such as the dry goods store on the right and the lumberyard farther on the left, prospered by serving local families and owners of summer cottages. (Photograph courtesy of Michael Parlante.)

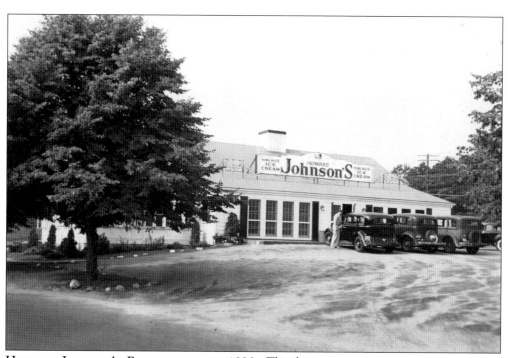

HOWARD JOHNSON'S RESTAURANT, C. 1933. This historic restaurant was America's first franchise of any kind. Howard Johnson opened a drugstore and soda fountain in Quincy in 1925. Lacking funds to open another, he franchised his name and recipes. In 1932, the first Howard Johnson franchise opened in Orleans at the fork of Routes 6A and 28, serving local families and the new generation of motoring vacationers. (Photograph courtesy of Michael Parlante.)

THE ORLEANS MOVIE THEATER, CORNER OF ROUTE 6A AND MAIN STREET, BY THE METHODIST CEMETERY. One of the few movie houses this far out on the Cape appeared in Orleans, as tourism continued to flourish. This photograph captures the scene in 1938, when Robert Taylor and Maureen O'Hara were starring in the film *The Crowd Roars.* (Photograph courtesy of Michael Parlante.)

A SEA SERPENT. On January 17, 1936, the newspapers reported: "Somewhere in the briny deeps that wash the Nauset strand, Orleans Coast Guards swear sea serpents with tongues shaped like fish tails, swivel-jointed necks and 200 teeth mounted in cavernous jaws stalk their prey. Surfman Fred Moll found the remains of such a critter on the beach below the station. . . . It was only a dolphin after all, according to Ed Taylor, John Nickerson and Everett Eldredge, Jr., after two days of research to identify the snaky skull."

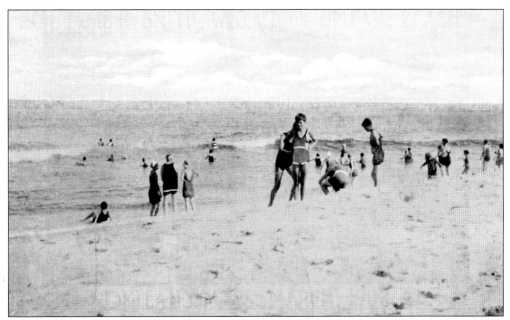

AN EARLY POSTCARD OF NAUSET BEACH, ORLEANS. With the Cape's Puritan background, it is not surprising that until the 1930s, many towns had a chin-to-knees beach-attire law. Cumbersome costumes were the rule until the lure of tourist revenue made modesty an economic liability. In 1935, the *Boston Sunday Post* reported, "No longer need bathers, sun or ocean, beach strutters, or shoreside paraders, fear the long arm of the law if they are not clothed from chin to knees." (Postcard courtesy of Mr. and Mrs. Stanley Snow.)

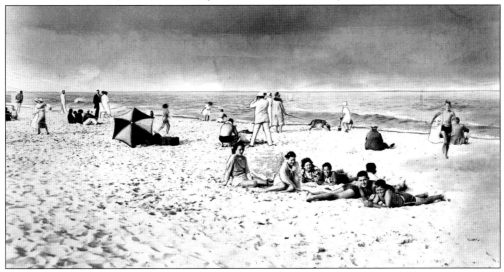

SOME BEACH BATHERS, NAUSET BEACH. "New Englanders never took seriously to sea bathing and beaching until about 1830, when Bostonians discovered that the ocean was useful for something else besides the sailing of clipper ships and the furnishing of sea food." One hundred years later, when modesty laws were repealed, the "designers of bathing costumes cut more and more out of them until from the back they were nothing but a pair of prizefighter's trunks, supplemented by a handkerchief." (*Boston Globe*, February 17, 1935. Photograph courtesy of Michael Parlante.)

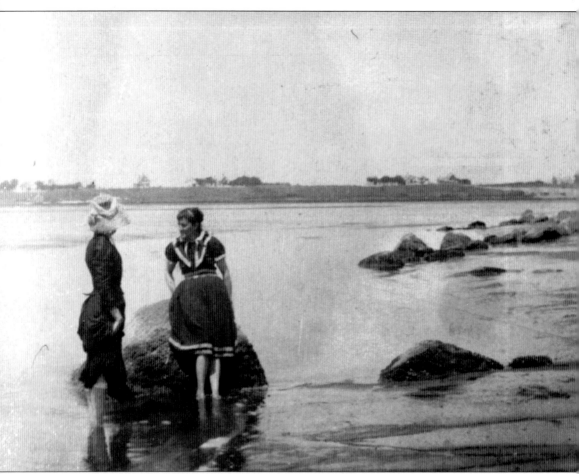

BATHERS AT ROCKY POINT, TOWN COVE. After Labor Day, the summer people leave Orleans to cross the Cape Cod Canal and make the sad transition to the mainland. Reaching home, they will remove their shoes and slowly pour sand into their hands. The crystals will fall, as if through an hourglass, and remind them of their brief time at the sea. They will be counting the months until their return, as they line a window sill with shells from Skaket Beach, Rock Harbor, and the dazzling reaches of Nauset Beach. (Photograph courtesy of Mr. and Mrs. Stanley Snow.)